IMAGES
of America

LIGHTHOUSES OF
LAKE WINNEBAGO

IMAGES
of America

LIGHTHOUSES OF
LAKE WINNEBAGO

Steve Krueger

ARCADIA
PUBLISHING

Published by Arcadia Publishing
Charleston, South Carolina

Printed in the United States of America

Library of Congress Control Number: 2016961371

For all general information, please contact Arcadia Publishing:
Telephone 843-853-2070
Fax 843-853-0044
E-mail sales@arcadiapublishing.com
For customer service and orders:
Toll-Free 1-888-313-2665

Visit us on the Internet at www.arcadiapublishing.com

This book is dedicated to my lovely wife, Deanna.

CONTENTS

Acknowledgments

Lighthouses of Lake Winnebago would not have been possible without help from the following organizations and individuals: Menasha Public Library, Neenah Public Library, Neenah Park and Recreation Department, Oshkosh Public Library, Oshkosh Park and Recreation Department, Fond du Lac County Historical Society, University of Wisconsin, Wisconsin Geological and Natural History Survey, Wisconsin Department of Natural Resources, and Amanda Haddox.

I would also like to thank the dive team members on the Menasha Lighthouse expedition, Chris Ederer, Gretchen Dominowski, and Mike Taylor. Lastly, a thank-you is owed to my son, Jonah, who came along to Lighthouse Reef to assist with the diving expedition.

Unless otherwise noted, all images are from the author's collection.

INTRODUCTION

When the average person thinks of a lighthouse, his or her mind naturally wanders off to the many coastal areas around the world where mighty beacons were erected to help sailing ships avoid the treacherous temperament and underwater landscape of the world's oceans. In the Midwest, many think of the old lighthouses perched upon cliffs and along the shores of the Great Lakes, where many ships have met their fate at the hands of the cold and deep abyss of 21 percent of the freshwater on earth. Few people realize the existence, or history, of the lesser lighthouses around the country, including Lake Winnebago.

Lighthouses have been used by man to aid waterbound vessels for over 2,000 years, with the first-known beacon being the Pharos of Alexandria, located in Alexandria, Egypt, around 285 BC. For many centuries after, the lighthouse function was primarily a harbor light to help ships find their way safely into port. The use of the light signal as a warning of danger to sailing ships did not mature until the 17th century.

The first lighthouse to be constructed in America was at Boston Harbor in 1716 while the new world was a British colony; however, the British government was not responsible for its construction. During that period, the colonial (local) governments had the responsibility to mariners to make the waters in their area safe. Many of the beacons within the United States were built as warnings to mariners of natural dangers, such as reefs and rocks. After the Revolutionary War, the newly created Congress created the administrative unit called the Lighthouse Establishment in 1778, which was responsible to determine where lighthouses needed to be built within the newly established country. The agency responsible for all lighthouses within the United States changed throughout the years and included the original Lighthouse Establishment, but then in 1852, the Lighthouse Board was the official government arm managing the lighthouses. The Bureau of Lighthouses came next in 1911, and the final move came in 1939 when the lighthouse management was placed with the current US Coast Guard.

The materials used to produce a light source in early lighthouses varied throughout the world and over time. Wood, coal, and wax were early, crude methods of producing light and were used in some beacons as late as 1905. Early on, simple open fires fueled by wood and coal were used inside of a metal basket known as a brazier. These fires were maintained on top of an elevated platform or natural high location next to the sea. Candelabras were also an early method to produce light, and most used tallow candles for the job, including America's first lighthouse in Boston Harbor. Oil lamps were another light source used as early as the 1500s with the earliest known design being the cresset. This design was made from stone, which was hollowed out into a bowl, and used solid rope as the wick. The oils used to fuel the lamps varied, with the most common being fish, seal, and whale oil. The pan lamp, compass lamp, and bucket lamp were next and provided an extended time between oil refills because of their holding capacity. These lamps would last around 12 hours before needing a refill, which gave the light keeper a little more downtime. Fountain lamps came onto the scene in the late 1700s and were superior to anything used up to that point. These lamps were able to regulate the amount of fuel reaching the wick and kept a consistent fuel level at the burner.

As the fuel and light source improved over time, so did the technology for refracting the light to produce a more intense signal. Crude, American-made parabolic reflectors were introduced in US lighthouses in 1812. The performance of these reflectors was very poor, and later, the government discontinued their use and imported higher-quality parabolic reflectors. Also in 1812, the first lighthouse maintenance contract was authorized by Congress. This contract covered every lighthouse within US territory and was awarded to Winslow Lewis, who had a patent for a reflecting and magnifying lantern. An advanced lens called the Fresnel hit the scene in 1823, which forever changed the quality and intensity of light beacons, along with lamp technology. A Fresnel lens uses many prisms (up to a thousand) in a design that takes the candlepower of a light source and amplifies it hundreds to thousands of times. Capillary lamps, overflow lamps, pneumatic lamps, hydrostatic lamps, and hydraulic lamps were all created to provide the light used in conjunction with Fresnel lenses.

In the end, though, technology caught up with the nostalgic fuel lanterns, and electricity came on the scene. The first structure in the United States to have its beacon powered by electricity lit up in 1886—it was the Statue of Liberty, which served 17 years as an official lighthouse beacon for the country. The first existing lighthouse that received the new technology in 1898 was located in Navesink, New Jersey. The advent of electricity brought about the end of permanent, on-site lighthouse keepers and the end of an era.

There are seven basic types of lighthouses and each have their own specific purpose. Coastal lights are medium-sized structures that mark coastal features such as islands and points. Harbor lights are small towers that are used by mariners to navigate into a harbor. Avoidance lights mark dangerous areas like rocky points and reefs. A leading light is a landmark lighthouse used when fixing a course along a waterway. Large lighthouses first spotted by water vessels as they near land are landfall lights, while range lights come in pairs and provide safe passage to vessels when they line the two lights up one above the other. Sector lights change color when a ship moves off course, indicating their current route is no longer safe.

The design of a lighthouse was based upon location, cost, need, and of course, politics. Prior to the mid-1800s, lighthouses needed to be built on solid rock or very stable soil due to the lack of technology to venture away from these solid foundations. Land-based lighthouses in the United States started with the very first lighthouse built in 1716 and have continued to the present. Straight wood pile foundations were used starting in 1828, followed in short order by the crib foundation, which was first used in 1832. Metal pilings were the next evolution in lighthouse foundations, with the straight metal pile making its debut in 1847 and the screw metal pile in hot pursuit in 1848. Disk metal piling foundations did not show up until 1858, followed by caisson foundations in 1867, which were the last foundation construction used in 1943, and the pneumatic caisson foundation in 1886.

The tower construction that sat upon the foundation had a timeline completely different than that of its underpinnings. Stone masonry was the first US lighthouse construction in 1716 and remained in command until 1755, when brick construction came into play. Wooden towers were not erected until 1784, and along with brick and stone masonry, wood remained the primary construction method until the early 1900s. Wrought-iron and cast-iron technology arrived in 1834 and 1844, respectively, with their improved counterpart, steel, being used much later in 1880. Later, more modern construction materials were used, such as reinforced concrete starting in 1908, Texas tower in 1961, aluminum clad in 1962, and fiberglass sometime in the 1960s.

Lake Winnebago had many lighthouses over the years, including one of those nostalgic lighthouses with the noble lighthouse keeper tending to its light. Today, six lighthouses remain along the shores of this shallow lake, and each one has its own beginning and reason for being there. Some were built out of necessity, while others were simply constructed to provide jobs during a downturn in the economy. Lake Winnebago has a rich and interesting lighthouse history, and the following pages tell the stories of the ones that remain, the ones that no longer exist, and the one that never got built.

One

LAKE WINNEBAGO

Lake Winnebago is in east central Wisconsin and is the largest body of water within the state's borders. Even though it is shallow, Lake Winnebago is notorious for providing opaque water conditions during the summer in conjunction with a pungent fish odor. These characteristics of the lake were well established long before white settlers entered the scene, as local Indian tribes named the lake "Winnebago," which means "filthy water" and called the tribe living upon its shores "people of the filthy water."

Nevertheless, the lake provided an abundance of fish and wildlife for anyone who settled along its shores and provided a source of power for European settlers who colonized the area. During the early years of white settlers in the region, Lake Winnebago and the connecting waterways were a vital lifeline that shaped and grew all communities along its shoreline. The only physical lake characteristic that has changed since the early 1800s is the depth. Once the settlers realized the potential within the flowing waters of the Fox River, they started building a dam and lock system to control the flow of water. The first dam in the system was built in Menasha, which caused the depth of Lake Winnebago to increase, resulting in the lake being two feet deeper today than it was 176 years ago.

Lake Winnebago provides year-round opportunities for anyone who wants to venture onto its surface. One of the state's top fisheries, the lake's murky waters have an abundance of panfish, walleye, sturgeon, and catfish. Bass fishermen can enjoy the thrill of the hunt for both smallmouth and largemouth bass, and top predators such as the muskie and northern pike swim below the surface. Fishing is just as good during the winter as it is in the summer, and it is very common to see shanty towns crop up on the frozen surface, even during the harshest winter conditions.

Boating is and always has been a desirable recreational activity on Lake Winnebago. With over 215 square miles of surface, it provides an ideal area for many different watercraft, but the shallow shoals on the 20-foot-deep lake bring risk to any mariner unfamiliar with the lake's underwater obstructions. For this reason, the lake has accumulated an impressive catalog of lighthouses built on or near its shores to aid vessels as they navigate the waters.

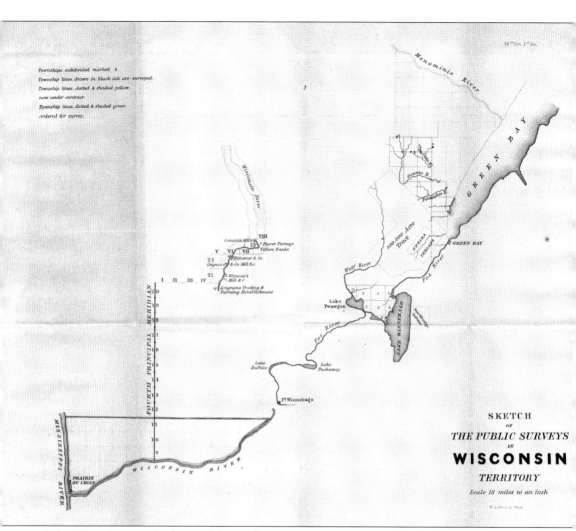

Lake Winnebago is the largest lake in the water system called the Winnebago Pool. It covers an area of approximately 137,700 acres and has an average depth of 15.5 feet, with a maximum depth of 21 feet. The west shore has many shallow reefs, causing many hazards for vessels trying to navigate the populated areas along the shoreline. It was these reefs that prompted the construction of many of the lighthouses along the shore.

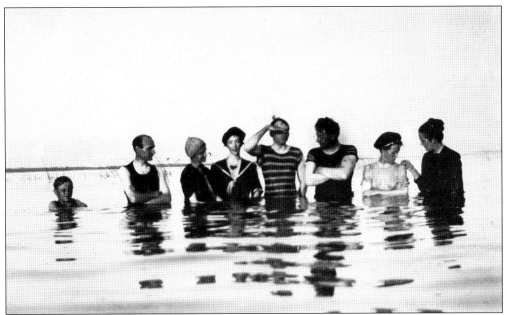

Lake Winnebago was, and remains, a gathering spot providing locals and visitors with many recreational activities. The shallow shores and natural algae blooms provide warmer water temperatures for swimming and wading. Eventually, beaches were built and maintained by local municipalities, allowing everyone to enjoy the warm, friendly summer water. (Courtesy of the Neenah Public Library.)

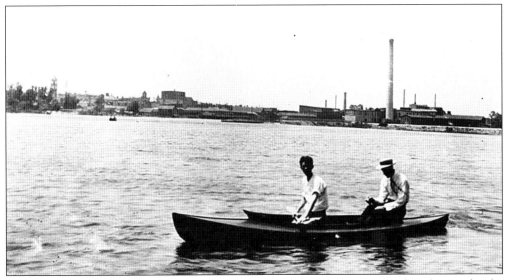

Canoeing was one of the many pastimes the local residents would partake of around Lake Winnebago. Before the full development of modern cities around the lake, Mother Nature provided a quiet and remote getaway from the industrial buzz that powered the area's economic growth. (Courtesy of the Neenah Public Library.)

Bountiful forests provided an endless supply of logs that would need to be floated down river to the various industrial companies that used them for paper pulp or for the manufacturing of wood products. Even though it was dangerous work and many lost their lives to the logging industry, it was a vital mainstay to the industrial areas along the lake. (Courtesy of the Menasha Public Library.)

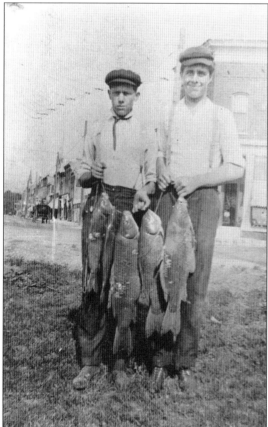

Lake Winnebago is home to over 18 species of fish, and until recently, all were caught and eaten, even carp like those pictured here. Fishing was not just a pastime for early residents, it was a necessity and staple of the dinner table. Lake Winnebago still is a thriving natural fish hatchery and draws fishermen from all over the Midwest. (Courtesy of the Menasha Public Library.)

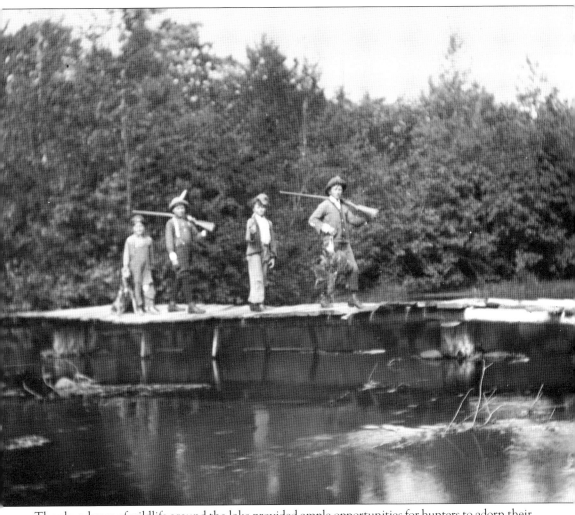

The abundance of wildlife around the lake provided ample opportunities for hunters to adorn their kitchen tables with fresh meat. In the earlier years, even the youngsters took part in supplying the family with a variety of waterfowl, turkey, deer, squirrel, and other mammals that inhabited the forest land surrounding their homes. (Courtesy of the Menasha Public Library.)

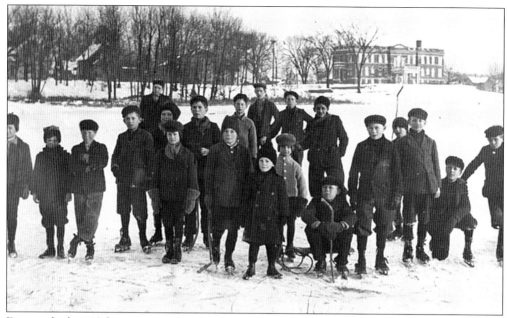

During the late 19th century and early 20th century, the shorelines of Lake Winnebago were a gathering area for youngsters to play and compete. Wintertime sporting activities included ice-skating, hockey, ice-fishing, and iceboating. Here, some young men pose for a picture off the shore in Neenah as they play ice hockey. (Courtesy of the Neenah Public Library.)

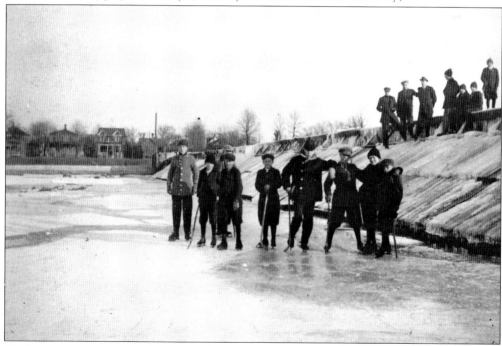

Hockey was a common youth sport in the wintertime around Lake Winnebago. The areas used to play would send shivers down anyone's spine today. Pictured above are a group of youths playing hockey directly below a dam, with some adults looking on. (Courtesy of the Neenah Public Library.)

Ice boating quickly became a competition all around Lake Winnebago. Many regattas were set up and neighbors would compete to see who could complete the course fastest. Many of the ice boat routes used the existing lighthouses as waypoints. (Courtesy of the Neenah Public Library.)

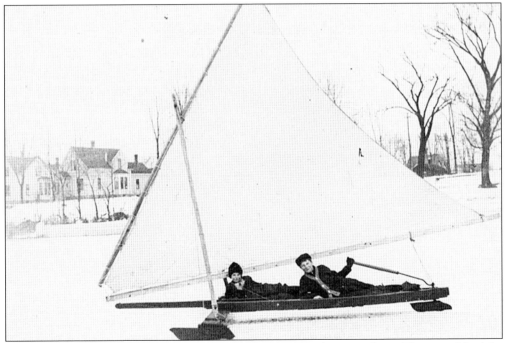

Iceboating was a very popular activity in years gone by on Lake Winnebago. The size of the lake allowed for long runs and even yearly competitions. Here, two boys are enjoying a ride in their homemade iceboat. (Courtesy of the Neenah Public Library.)

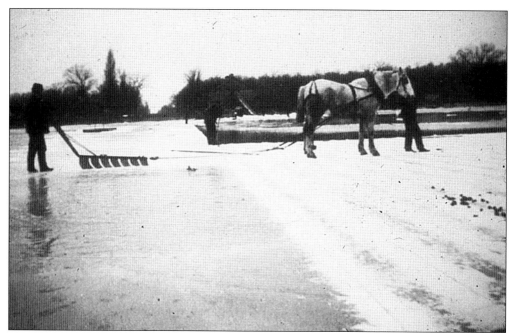

Ice harvesting was a booming business around Lake Winnebago before the invention of refrigerators. The only way to keep perishable foods from spoiling was to keep them in an ice box. Each family would need to purchase ice from local companies and place the blocks inside their ice box in the kitchen. (Courtesy of the Neenah Public Library.)

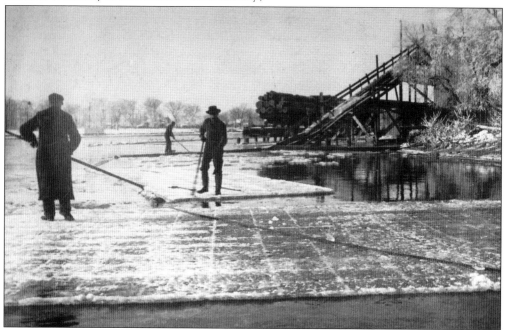

Icemen would ride the larger cut pieces of ice while steering the smaller cut pieces to an area where they would be loaded onto wagons and brought to an insulated icehouse (normally close to the shoreline) for year-round storage. Ice harvesting normally took place once the thickness of the ice reached at least 12 inches. (Courtesy of the Menasha Public Library.)

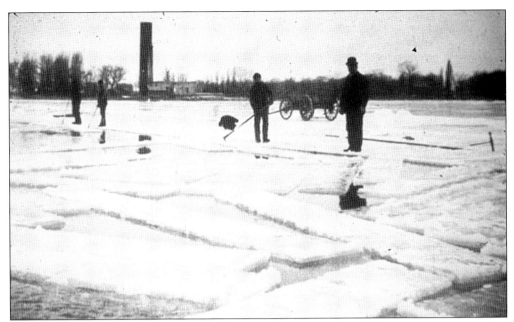

Being an iceman on Lake Winnebago was a very dangerous job and the entire process required from 20 to 200 men, depending on the size of the operation. The entire harvesting season was about four weeks long and required all snow on top of the ice to first be scraped away. The workers would then measure a grid pattern and have a horse pull a cutting tool to mark the ice. The men would then cut along the marks with a saw and float the ice pieces to the icehouse. (Courtesy of the Neenah Public Library.)

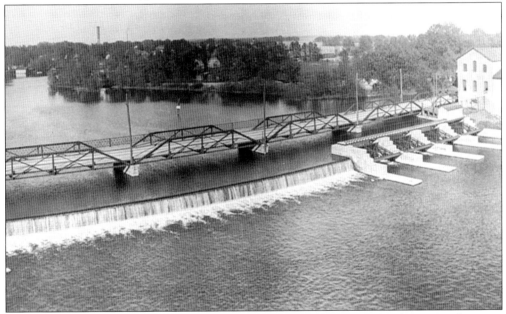

Before the two dams were built on the north end of Lake Winnebago in the 1800s, the water level of the entire lake was actually lower than it is today. The increased water depth benefited the area by increasing the available water power to operate mills along the Fox River. (Courtesy of the Neenah Public Library.)

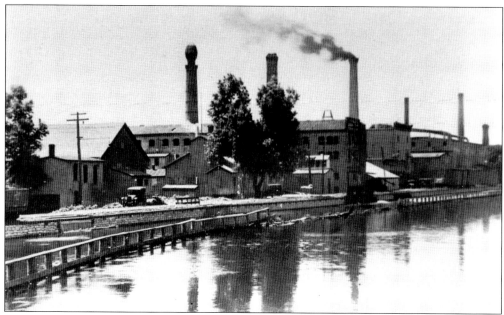

All mills along the shores of the Fox River were dependent on Lake Winnebago supplying them with water power and customers. Water was the main means of travel for the early settlers, and every industry made provisions to accommodate the use of the Winnebago system. (Courtesy of the Menasha Public Library.)

Not all water travel was commercial; leisure travel became a booming industry around Lake Winnebago. The wealthy would have personal yachts built by local ship builders, like the one pictured here, and proudly traveled around the Winnebago system. (Courtesy of the Menasha Public Library.)

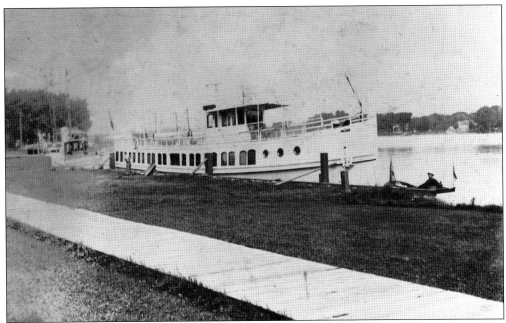

Yachts were commonplace among the well-to-do residents who lived on Lake Winnebago. The *Cambria* (pictured here) was a 90-foot-long steam-powered yacht owned by John Steven of Neenah. She was rebuilt in 1907 to allow more cabin space and better stability on larger bodies of water. The *Cambria* often traveled from Lake Winnebago to the Great Lakes. (Courtesy of the Menasha Public Library.)

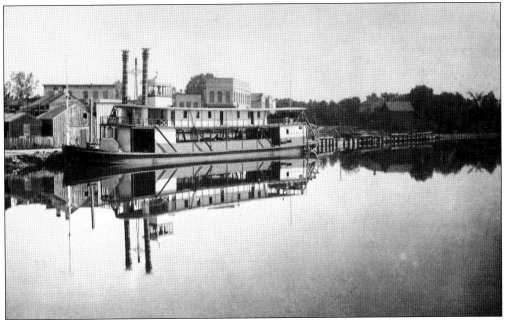

The *K.M. Hutchinson* was one of many stern paddlewheel boats that roamed the waters of the Fox River and Lake Winnebago, and is pictured resting at the Menasha dock. Built from an older barge, she was a workhorse of the lake and even carried C Company of the 2nd regiment from Sheboygan on one of their journeys. (Courtesy of the Menasha Public Library.)

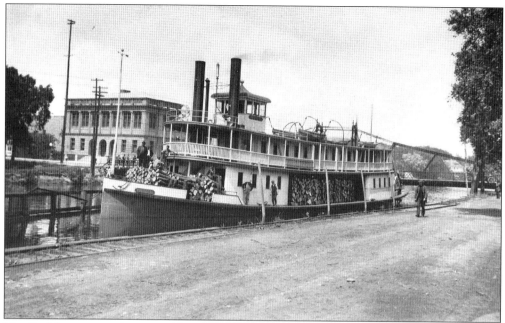

The *Paul L.* was an industry workhorse, carrying many raw materials to various mills along the Fox River, including this load of cedar logs for the Menasha Wooden Ware Company. The ship was also used to carry coal in the early 1900s. On May 28, 1910, the *Paul L.* capsized when the shipment of coal she was carrying was unevenly removed, causing her to roll sideways into the Fox River. (Courtesy of the Neenah Public Library.)

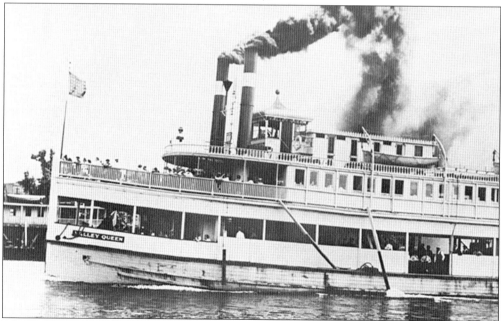

The *Valley Queen* was a gorgeous passenger vessel on the waters around the area. The ship, like many, was built from an older vessel (called the *Leander Choate*) and her fate, unfortunately, was also common for that era. The *Valley Queen* ran one season before she was destroyed by fire in Oshkosh. (Courtesy of the Neenah Public Library.)

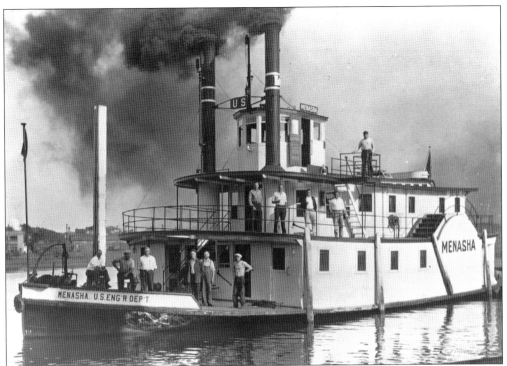

The US Engineering Department also had a fleet of vessels on the Winnebago system including the *Menasha* (pictured), *Neenah*, and *Fox*. This fleet was responsible for all government work on the system including dams, locks, and navigation buoys. The *Fox* was the vessel designated to erect and remove the two Menasha lighthouse beacons in the early 1900s. (Courtesy of the Neenah Public Library.)

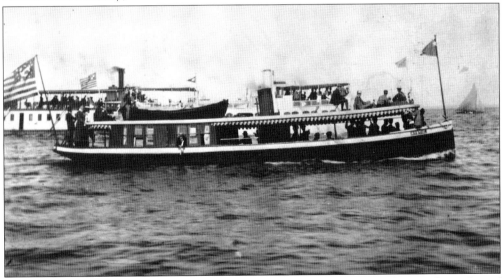

The *Mystic* was a smaller steam powered excursion vessel that carried people over the surface of Lake Winnebago. Many smaller pleasure boats like this dotted the area's waterways. The immense amount of increased boat traffic gave rise to the need for improved navigation lights along the system. (Courtesy of the Menasha Public Library.)

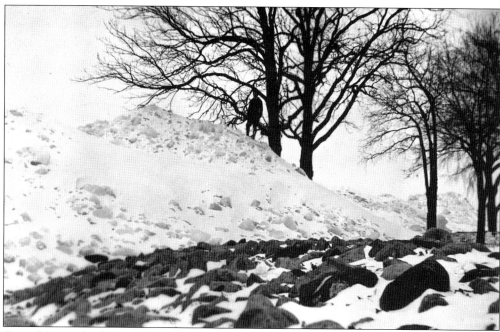

One of the perils of Lake Winnebago are the ice shoves that can develop along the shores during the winter. Strong winds break up the ice on the lake and push the sheets towards shore, where they pile up onto each other, causing mini glaciers that can reach 25 feet in height. (Courtesy of the Wisconsin Geological and Natural History Survey.)

At times, the ice shoves along Lake Winnebago are so violent that residents describe the noise they make as akin to a freight train passing by. The shoves have been known to destroy docks, and if large enough to move farther on shore, have pushed homes and other structures off their foundations. (Courtesy of the Wisconsin Geological and Natural History Survey.)

Two

MENASHA LIGHTHOUSES

Between 1855 and the early 1900s, Menasha had three lighthouses to help boats navigate the shallows and channels of Lake Winnebago and the Fox River. Two of the lighthouses were located on Lighthouse Reef on Winnebago, and the other was on the other side of the Menasha locks in Little Lake Butte des Morts. The largest, and first ever on the lake, was established in 1855, while the other two located on both ends of the channel were in operation starting in 1898.

The history of the Menasha lighthouses is what prompted the development of this book because they are two of the least known navigation beacons from the bygone eras of Lake Winnebago and the least understood. Unfortunately, the anecdote told in the past about their history is more folklore than fact, and the inaccuracies stem as far back as 1905 with a story told by the Wisconsin Historical Society. Embellishments were added to many earlier accounts of facts to either enhance the story or fill in missing details. The first, Menasha Lighthouse, did not escape the added extras being attached to its already interesting history.

The repeated historical tale, or a variation of it, has been reprinted for over 120 years by local and state historical societies, and a local paper as recently as 1954. Sadly, the actual story only muddied the waters of reality, including the lighthouse keeper's name. For over a century, the account named Jerry Crowley as the appointed lighthouse keeper, when in fact he was the owner of the *Menasha Advocate* newspaper. The lighthouse keeper was Dennis Crowley, and that one single erroneous mishap of publishing wrong information started a research quest for the facts, which took the author of this book all the way to the National Archives.

The old account printed by the Wisconsin Historical Society, and repeated by the local historical society and newsprint, was riddled with incorrect information including the lighthouse keeper's name, the layout of the lighthouse, where materials came from to build the lighthouse, the government lighthouse inspector, how the lighthouse became abandoned, and when the structure disappeared from the Lake Winnebago landscape.

Even though very few records remain that give details to the oldest lighthouse on Winnebago and its later cousins, this chapter contains never-before-seen documents and is the most complete and accurate account of Menasha's lighthouse history.

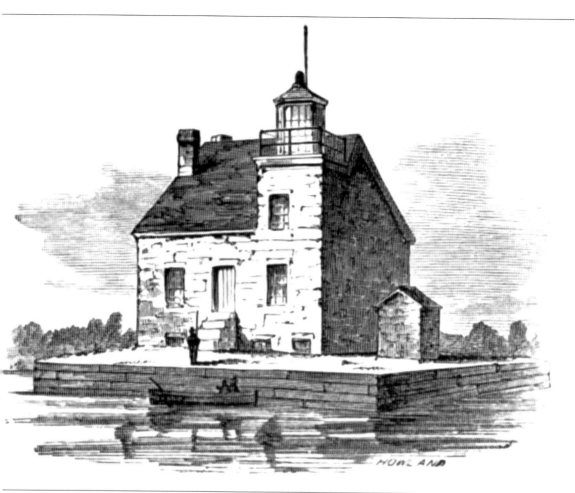

The very first lighthouse to spread its light across the waters of Lake Winnebago was in Menasha. Not only was it the first, but it was also the only lighthouse ever built on the lake that contained living quarters for the lighthouse keeper and his family. The official plans began being drawn on November 24, 1853, and the lighthouse was put into service in July 1855, during the midst of the navigation season. The total cost for the project was $5,000, which would be a little more than $67,000 today. The contract to build the lighthouse was awarded to Alanson Sweet and L. Ransom, who also received contracts to build seven other lighthouses in the Midwest at the same time. The lighthouse only saw one keeper in its short four years of operation, and his name was Dennis Crowley. Crowley was appointed to serve as lighthouse keeper on September 17, 1854, and remained until the light was decommissioned in August 1859 due to an act of Congress. The building was shuttered, and the key was brought to the collector of customs in Green Bay. Eventually, the structure succumbed to a fire and ice shoves, which left little recognizable parts of the building remaining besides a few portions of walls by 1878. No photograph was ever taken of the lighthouse, and this drawing is the only known rendering of what the structure looked like.

James Doty was a member of Congress during the 1850s (and later became the territorial governor of the area) and was instrumental in helping to shape the Fox River area into an industrial powerhouse. Doty was the driving force in convincing the federal government to fund and build the first lighthouse on Lake Winnebago. It was constructed offshore from Menasha. (Courtesy of the Neenah Public Library.)

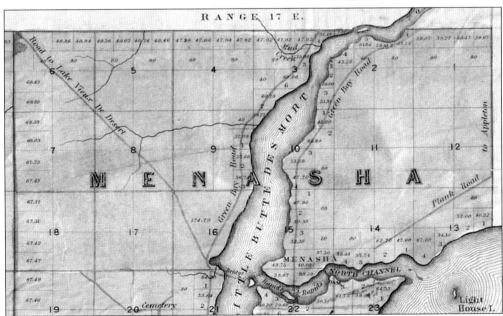

Menasha was a growing industrial city, and boat traffic was an ever-increasing means of travel for leisure and commerce. The shallow areas around the entrance to the north channel around Menasha were a hazard to vessels, so the US government built the area's first lighthouse on what was eventually called Lighthouse Island.

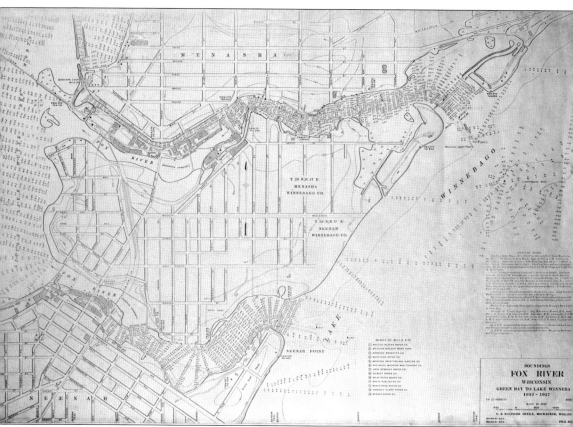

Prior to the US Engineer Office's mapping of Lake Winnebago from 1932 to 1937, the exact location where the lighthouse once stood was lost to the memories of those who lived during that time. The only account on record as to the exact location was in a *Menasha Advocate* newspaper article from 1855, which stated that the structure was built 80 rods from shore, which equals 1,320 feet. The precise location is shown on this government survey map where the water depth shrinks to zero on a shallow rock barrier now called Lighthouse Reef. (Courtesy of Diane Schabach.)

The location of the Menasha Lighthouse, while standing on the northwest shore of Lake Winnebago, was approximately 1,320 feet to the east of the land point on the right side of the picture located at the mouth of the north channel.

Even more mysterious than the lighthouse itself was the keeper, Dennis Crowley. There are only a few scant records that even mention his name, and one is this official US lighthouse keeper logbook, which recorded each lighthouse keeper's name and salary. A lighthouse keeper's salary was offset by the value of the living quarters the government supplied for them and their families. On average in the mid-1800s, US lighthouse keepers were given a salary of $350, which equates to approximately $9,000 today.

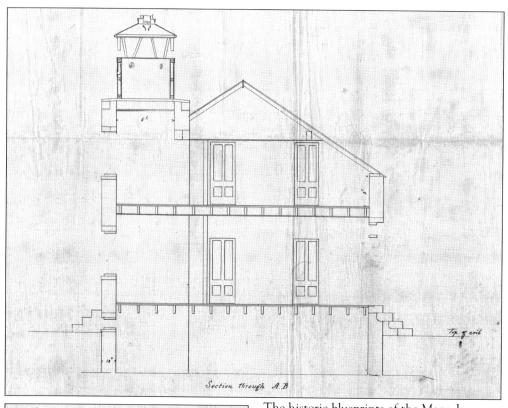

Section through A.B

Plan of Crib

The historic blueprints of the Menasha Lighthouse, located in the National Archives, are the only remaining official documents that give insight to what the structure looked like inside. It was a two-story structure with 18-inch exterior walls and a cellar for storage. Access to the lantern was directly off the bedroom where the keeper slept.

The Menasha Lighthouse was one of only two crib lighthouses built on Lake Winnebago. The crib was built of timber onshore, towed out to the location, and filled with rock to hold it in place; then, the lighthouse was built inside the crib opening. The entire crib measured 56 feet square by 4 feet high. The opening for the lighthouse cellar measured 34 feet square.

The first floor contained the parlor room and kitchen; each of the rooms had a separate fireplace and were connected by a door. A small pantry and hallway took up the remaining area. There were two doors on opposite sides of the lighthouse that led out to the 11-foot-wide crib deck.

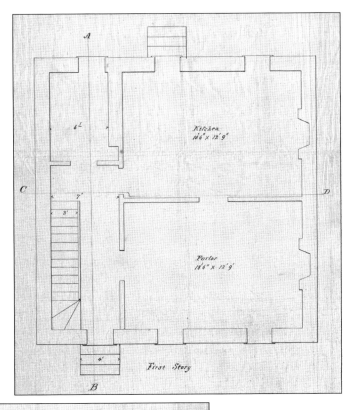

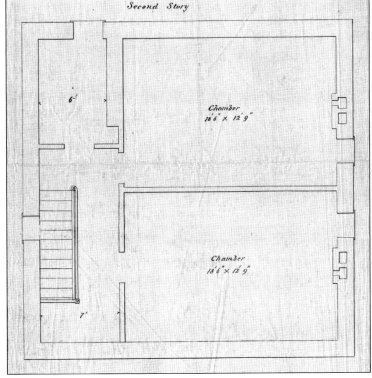

The second floor contained two bedrooms and the access room, which held the ladder the keeper had to climb to the lantern. The light used was a simple stationary lantern, which shone out toward the southeast; the lantern deck did not have glass facing the northwest, which prevented light from unnecessarily shining onshore.

Quarried stone from around Lake Winnebago was used to fill in the wooden crib and hold it to the reef. The bricks that were used to construct the exterior walls of the lighthouse were supplied by Mesars, Blake & Matheous, which was contracted by Alanson Sweet & Co., the company in charge of building the lighthouse. The brick makers made a total of 12 million bricks, which were used in the construction of eight lighthouses including the one in Menasha. (Courtesy of the Neenah Public Library.)

The Menasha lighthouse had to endure the powers of Mother Nature, including ice shoves. These massive walls of ice would build up from the wind racing across Lake Winnebago and could push homes off their foundations. At times, these walls of ice could reach 25 feet in height. (Courtesy of the Neenah Public Library.)

30

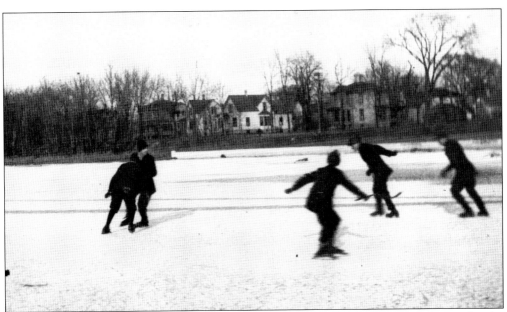

The Menasha Lighthouse was decommissioned in August 1859 after it was determined to be unnecessary. It stood intact until 1879, when several boys ice-skating on the lake went inside and lit a fire to warm up. The surrounding woodwork caught on fire, and the entire inside of the lighthouse was gutted. (Courtesy of the Neenah Public Library.)

Over the remaining years, the destructive force of ice shoves on Lake Winnebago took their toll on the dilapidated structure, eventually pushing the remains into the lake. Today, nothing remains of the lighthouse besides the shallow rock reef that once supported it, and a few crib timbers. (Courtesy of Wisconsin Geological and Natural History Survey.)

The remains of the original crib belonging to the first Menasha lighthouse still rest quietly on the bottom of Lake Winnebago. Until 2016, it was thought that no structural elements of the lighthouse remained. The author led a dive expedition to try to find the exact location where the beacon stood. Here is a picture of one of the crib timbers found on the dive.

The timber used to make the crib was oak. Each piece of intact crib was approximately 10 to 12 feet long, 12 inches wide, and 6 inches high. This two-foot section, which was found on the dive, weighs 42 pounds, making a full section of timber weigh approximately 250 to 300 pounds.

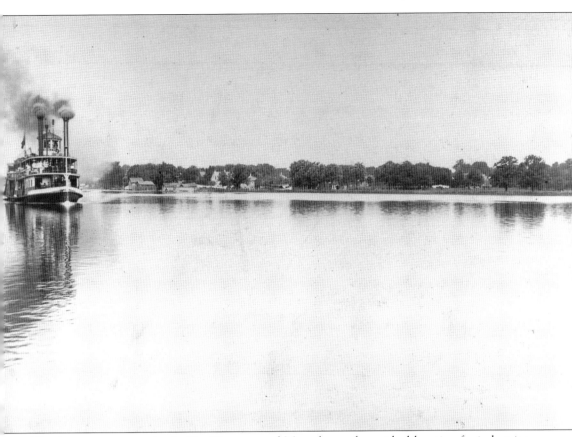

The fast-moving water in the Fox River around Menasha made an ideal location for industries such as flour mills, paper mills, and others. The area also became a stop for steamboat travelers making their way to Green Bay or to the south end of Lake Winnebago. The increased boat traffic was one of the driving points to build the government lighthouse on the reef just off Menasha. (Courtesy of the Neenah Public Library.)

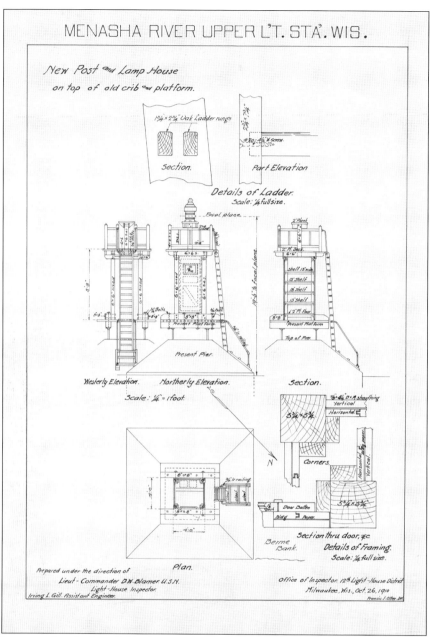

MENASHA RIVER UPPER L'T. STA'. WIS.

New Post and Lamp House on top of old crib and platform.

Details of Ladder.
Scale: ¼ full size.

Westerly Elevation. *Northerly Elevation.* *Section.*
Scale: ¼ = 1 foot.

Plan.

Details of Framing.
Scale: ¼ full size.

Prepared under the direction of
Lieut - Commander D.W. Blamer. U.S.N.
Light-House Inspector.
Irving L. Gill. Assistant Engineer.

Office of Inspector. 12th Light-House District
Milwaukee, Wis., Oct. 26, 1910

It was determined in the late 1800s that another navigation light was indeed needed at the mouth of the north channel in Menasha due to many boats running into the shallow reef in the area. By this time, the Menasha Lock was complete, and the US government built two lighthouses for navigating the channel, one near the location of the old Menasha Lighthouse and the other on Little Lake Butte des Morts for navigation into the lock. Both of these lighthouses were lit with gas lanterns, but the lighthouse keepers lived on land and rowed out to the beacons each day to refuel and maintain them. Both had crib structures as a base and were made entirely out of timber with a red lens for the light. They stood 19.5 feet tall, with the one located on Lake Winnebago being erected on an existing earlier beacon crib that was constructed for a lighthouse that did not have a long lifespan.

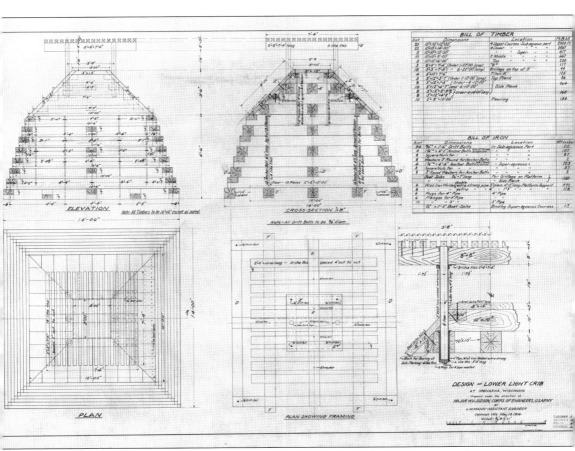

The wooden crib for the lower lighthouse on Little Lake Butte des Morts was in deeper water than its sister on Lake Winnebago. The lower crib was 6.5 feet tall and 14 feet wide at the base. As with the upper crib, the lower was filled with rocks to hold the structure to the lake bed.

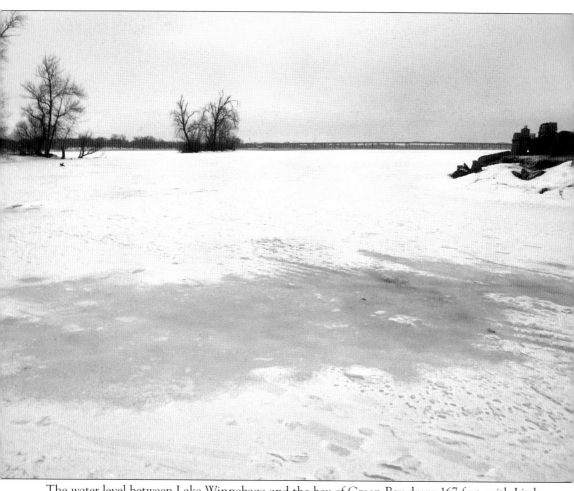

The water level between Lake Winnebago and the bay of Green Bay drops 167 feet, with Little Lake Butte des Morts being the first lower section. To help the early boat traffic navigate the waters to the Menasha Lock, a lower lighthouse was installed in the area near the locks.

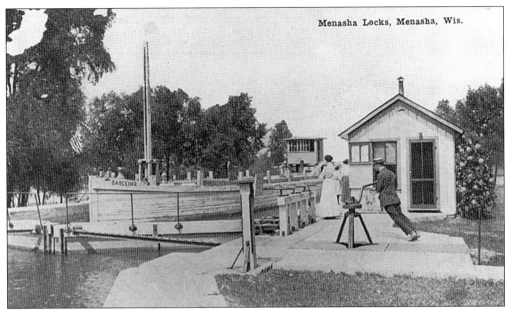

To move manufactured goods from the area to the northern territory of Green Bay, a series of locks were constructed that allowed boats to navigate the large drops in water levels as the Fox River drained north. Each lock along the route was manpowered. (Courtesy of the Menasha Library.)

The Lake Winnebago and Fox River waterways were also utilized for pleasure cruising and mass transport of people in northeast Wisconsin. Menasha's locks became a familiar stop for steamships as the water level was lowered or raised, allowing the boats to continue along their voyage. (Courtesy of the Menasha Library.)

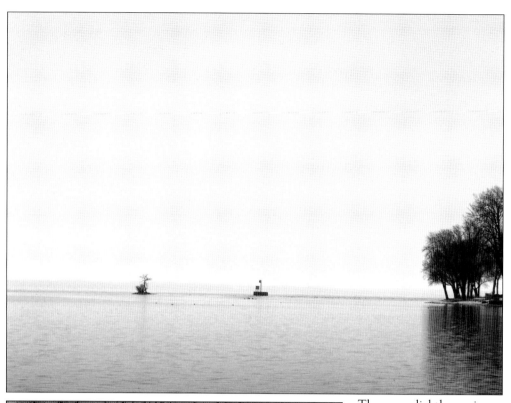

The upper lighthouse in the early 1900s on Lake Winnebago was built just to the west of where the original 1855 lighthouse was located. Today, the modern navigation light named Buoy 100 is in the exact location of the old light beacon.

John Arft was the light keeper for the upper beacon, and Henry Lenz was keeper to the lower beacon on Little Lake Butte des Morts. Each keeper was given a salary of $25 per month to maintain the beacons during the navigation season.

Three

NEENAH LIGHTHOUSES

In 1835, the area of modern-day Neenah started out as an industrial and agricultural mission for the Menominee Indians. Originally called Winnebago Rapids, the area was incorporated as Neenah in 1856. The word Neenah means "running water" in the Ho-Chunk native tongue. During the early 1800s, Neenah was in a head-to-head battle with its neighbor directly to the north, Menasha, as both communities struggled to get a foothold as the industrial city and competed for the commercial and recreational traffic scurrying about Lake Winnebago.

In the end, many industrial operations were established in both Neenah and Menasha, but Neenah became the preferred place to set up residency by those who owned and operated the companies. Names such as Bergstrom, Gilbert, Kimberly, and Clark called Neenah their home, and their generosity for the area was not in short supply. Much of the parkland within the city was donated by these affluent residents, including the land that the Neenah Lighthouse sits upon.

There was no bigger or more contentious battle between Neenah and Menasha than the competition for early boat traffic. Both cities were striving to become the center for navigation, and both began to build a lock to provide passage for boat travel down the Fox River from Lake Winnebago. Neenah finished before Menasha, completing its lock in 1852; however, the Menasha route became the official government channel, and the Neenah Lock was abandoned around 1866.

Neenah grew into an industrial contender because of the river system that flowed through it. Entrepreneurs harnessed the waterways and first established the area as a flour and lumber mill hub. It did not take long after that for the paper industry to gain traction along Neenah's waterways, which set the city's future in stone.

The Kimberly Point lighthouse was a joint development between the City of Neenah and the Kimberly family. First discussed in 1939, the lighthouse became an important project for the city and its residents in an area of Doty Island where much of the shoreline was preserved for public

parks. The Parks Department proposed an ornamental lighthouse be built at the tip of Kimberly Point, and plans were immediately expanded to include restrooms at the base of the lighthouse. Very few historical photos of the Kimberly Point lighthouse exist. (Courtesy of Amanda Haddox.)

The current lighthouse sits upon land that originally belonged to the Kimberly family. It was used for many things, including a grazing area for the family's livestock. Much of the parkland along the shoreline on Doty Island was donated to the city by the Kimberly family. (Courtesy of the Neenah Public Library.)

John Alfred Kimberly was one of four men who started Kimberly, Clark & Company in 1889 along with Charles B. Clark, Frank C. Shattuck, and Havilah Babcock. The company became very successful and soon propelled the founders into the social elite of the area. (Courtesy of the Neenah Public Library.)

John Alfred Kimberly and his wife, Helen Cheney Kimberly, became lead socialites in Neenah and owned many acres of land throughout the area. Some of the family land would later be donated to the city for parkland by their daughter Helen Kimberly Stuart. (Courtesy of the Neenah Public Library.)

Helen Kimberly Stuart used her prominent status for the betterment of Neenah by forming the Neenah League of Women Voters, was elected to the Neenah Board of Education, served on the Neenah City Council, and ran for Neenah mayor. One of her biggest battles was taking on the very company her father helped create, the Kimberly-Clark Company. (Courtesy of the Neenah Public Library.)

Kimberly Point came under assault by Kimberly-Clark president F.J. Sensenbrenner when he attempted to purchase all the land that made up the point in order to build a multimillion-dollar estate. Helen Kimberly Stuart vigorously fought against the plan and eventually won. She then donated the land, currently home to the Kimberly Point Lighthouse, in 1929. (Courtesy of the Neenah Public Library.)

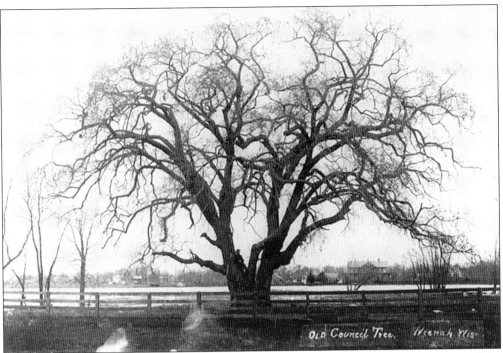

Neenah's Old Council Tree was a historic natural landmark near the current location of the Kimberly Point Lighthouse. The tree was a meeting place where white settlers and Native Indians would sit and discuss any issues that were a concern to either party. The tree was later removed due to old age. (Courtesy of the Neenah Public Library.)

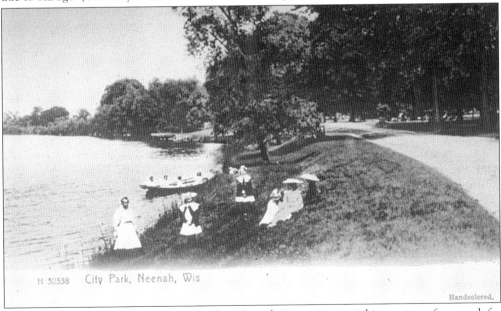

Once the Kimberly property was donated to Neenah, it was converted into a waterfront park for residents to enjoy. The area became a gathering place for boaters as much as it was for pedestrians. The two parks are still there today and are located where the Fox River meets Lake Winnebago in Neenah.

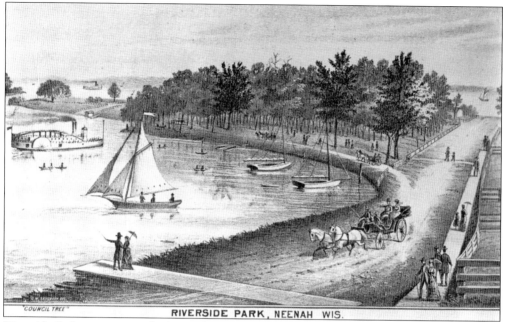

Riverside Park continues to be Neenah's premier parkland. This 1800s illustration shows what the parkland used to look like, with the future site of Kimberly Point at top left. The Old Council Tree is visible near where the lighthouse would be built decades later. (Courtesy of the Neenah Public Library.)

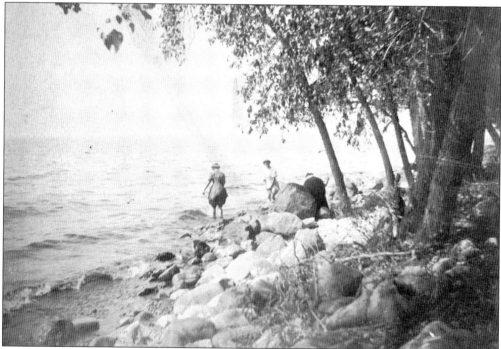

The shoreline around Kimberly Point was a common attraction for residents. Besides providing excellent fishing opportunities with much of the rocky shore and river bottom, the water was popular for boating, swimming, and wading, as seen here. (Courtesy of the Neenah Public Library.)

The Kimberly Point Lighthouse lamp is electric, but the approach to the lantern is a steep climb on wooden ladders. The entrance to the tower is in the women's restroom, where people can easily look through the metal grate hatch to catch a glimpse of the 49-foot climb.

In 1954, the Neenah Parks and Recreation Board approved a plan to increase the height of the lighthouse by 8.5 feet to better aid boaters on Lake Winnebago. When Flour Brothers Construction Company first built the lighthouse, the brick and Haydite tower reached 40.5 feet.

The only time the tower is entered is for maintenance and repairs. The Kimberly Point Lighthouse was placed in the municipal Register of Historic Places in 2009; the Wisconsin State Register of Historic Places followed suit in 2012. The lighthouse was listed in the National Register of Historic Places in 2013.

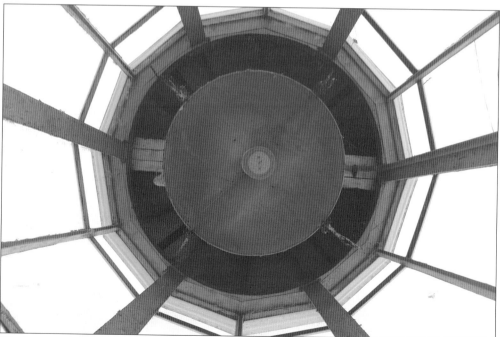

The lantern deck is very small, with very few footholds besides the ladder. The electric lantern is maintained by the Neenah Parks and Recreation Department, and the lighthouse is still used today to help guide boats into Neenah's harbor.

The light from the Kimberly Point Lighthouse can be seen over eight miles away on a clear night. Prior to the additional 8.5 feet being added in 1954, the light had a range of roughly 7.5 miles out on Lake Winnebago.

The lantern deck is surrounded with glass, which allows the light to shine in all directions, including onto shore. The lighthouse is a well-known landmark for boaters, ice fishermen, and recreational snowmobile enthusiasts, who use the lake to travel from one point to another.

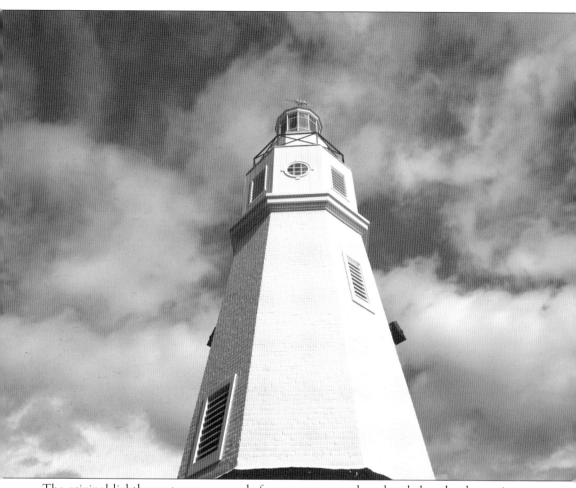

The original lighthouse tower was made from masonry work and ended at the decorative cap overhangs. The additional 8.5-foot extension was constructed of wood. The original lantern deck was removed during the addition's construction but was promptly placed atop the new section once it was completed.

Four

OSHKOSH LIGHTHOUSES

Oshkosh is another industrialized location on the shores of Lake Winnebago due to the waterpower provided by the Fox River feeding into the lake. Just like Neenah and Menasha, the location was ideal for harnessing the water to provide power to lumber mills. The land was ceded to the US government by the Menominee Indians in 1836 and named after Chief Oshkosh, which meant "The Claw" in the Ojibwe language. The city was nicknamed "Sawdust City" due to the 15 shingle mills, 24 sawmills, and 7 sash/door manufacturers it had by 1873. These sought-after and needed commodities were shipped out of the city by rail and water. From Oshkosh, water vessels traveled both to the north to reach Green Bay and south to the Wisconsin River and eventually the Mississippi River.

Oshkosh was a magnet for the general populous because of the ample supply of jobs in the area, and this attraction proved beneficial to the city in the late 1800s, when it was the third-largest city in the state. The city's industrial base was one to be admired, and it did not take long for the lumber industry to be overshadowed by an ever-increasing movement to more advanced and modern manufacturing.

Today, the waterways of the city of Oshkosh are used by recreational boaters, as the commerce of the past is all but a distant memory. The downtown historic district is a staunch reminder of the golden days when the lumber industry built a great city. Today, the area is better known for aviation and heavy commercial vehicle manufacturing.

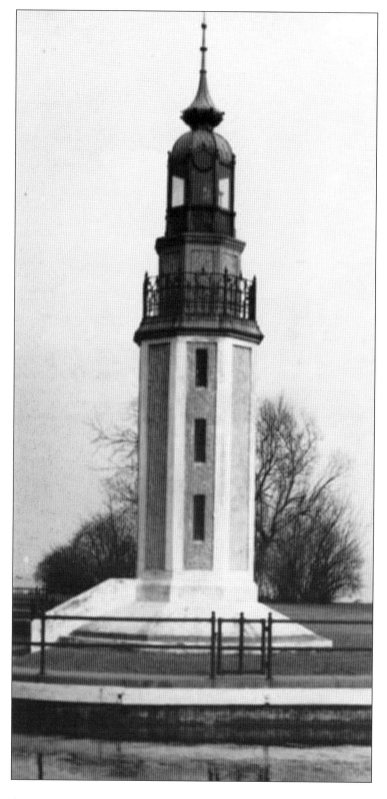

Oshkosh is the only community along the shores of Lake Winnebago to contain two lighthouses. The most ornate of these is commonly called the Bray's Point Lighthouse. It is also known as the Buckstaff, Thompson Point, and Rockwell, as the structure was commonly named for those who owned the property over the years or for the person who designed the structure.

William M. Bray.

WINNEBAGO COUNTY.

First District. The town of Oshkosh and the 1st, 2d, 4th, 5th, 7th, 8th, 10th, 11th and 12th wards of the city of Oshkosh. Population, 1900—20,317.

WILLIAM M. BRAY (Rep.) was born in Oshkosh, Wisconsin, March 17, 1880, and was educated in the public schools of that city, also spending three years at Northwestern University of Evanston, Illinois, and one year at Harvard. He has been engaged in the lumber business on the Pacific coast and in the southern states since leaving school. Mr. Bray was elected to the assembly in 1908, receiving 2,590 votes against 1,897 for Herbert Jensen (Dem.), 148 for B. F. Baldwin (Pro.), and 121 for G. T. Thom (Soc. Dem.).

There were many requests for a government lighthouse on the shores of Lake Winnebago in Oshkosh that fell upon deaf ears in the early part of the 20th century. These included denied requests for a light at Gruenhagen's Point (now called Bray's Point) in 1908 and for a beacon to be placed on top of the old clock tower of the waterworks filtration plant on Washington Boulevard in 1938. In 1909, Wisconsin senator William Bray took it upon himself to build his own lighthouse off the shore of his property to mark the dangerous reef within the lake. The lighthouse was designed by local architect George Rockwell, but unfortunately, Rockwell did not live long enough to see his creation built. (Courtesy of the Oshkosh Public Library.)

Bray entertained many dignitaries at his home and property, including Pres. William Howard Taft in 1911. While in town on a campaign trip, President Taft stayed the night at the Bray home. (Courtesy of the Oshkosh Public Library.)

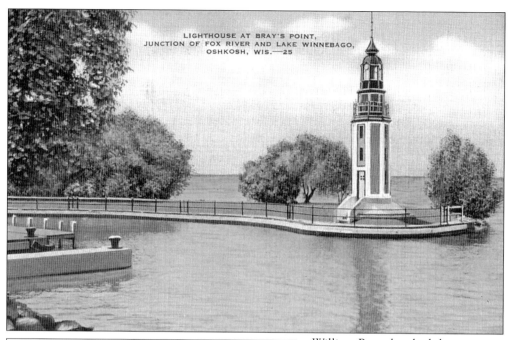

LIGHTHOUSE AT BRAY'S POINT,
JUNCTION OF FOX RIVER AND LAKE WINNEBAGO,
OSHKOSH, WIS.—25

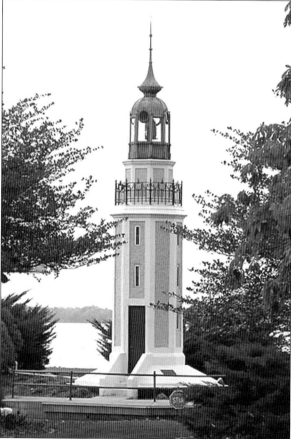

William Bray absorbed the operating costs of the lighthouse until 1917, when the US government licensed the lighthouse as an official navigation beacon. In the early life of the lighthouse, the structure saved a few lives, including three men whose boat started taking on water in rough conditions in 1911. The lake was so choppy that the waves came over the sides of their boat and it started sinking. The three men saw the light from Bray's Point and headed in that direction, where they were rescued.

Bray eventually moved to Oregon and sold his home and lighthouse to Harry Stutz in 1917. Stutz was the manufacturer of the Stutz Bearcat Automobile. For the three prior years to Stutz owning the property, the lighthouse remained dark. Stutz gave the orders to relight the red beacon in the lighthouse for the benefit of boatmen during navigation seasons. (Courtesy of the Oshkosh Public Library.)

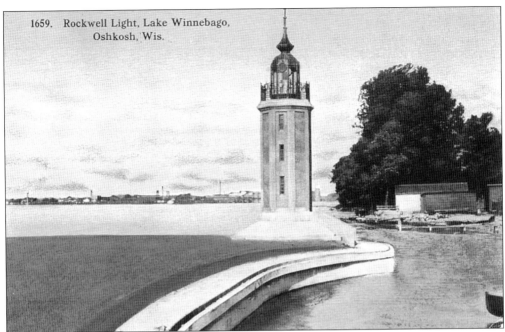

1659. Rockwell Light, Lake Winnebago, Oshkosh, Wis.

Just 16 months later, Stutz sold the property to Frank Wheeler, who was part of the Stutz Corporation. Just as fast as Wheeler gained the property, he sold it to John Thompson later that year in 1918. Thompson repaired the lighthouse and enlarged the home that sat on the shoreline.

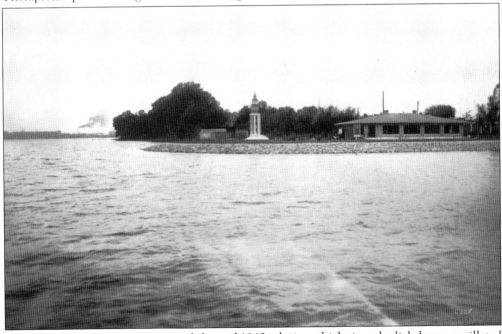

Thompson owned the property until the mid-1940s, during which time the lighthouse vacillated between being operational and being retired. In the late 1920s, Mrs. Thompson was listed as the keeper, and a group of watercraft owners paid for the lighthouse's upkeep. During the Thompson ownership, the light was the only government-licensed inland lighthouse. (Courtesy of the Oshkosh Public Library.)

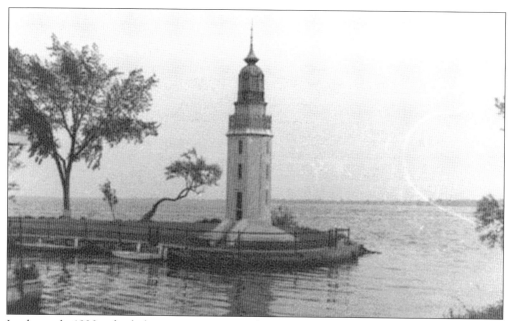

In the early 1930s, the light once again went dark. Operators of commercial steamships and small gasoline-powered boats approached John Thompson in 1933 and requested the lighthouse once again shine its beacon on the waters of Lake Winnebago. Thompson agreed and obtained special permission from the Department of War to fire up the beacon. (Courtesy of the Oshkosh Public Library.)

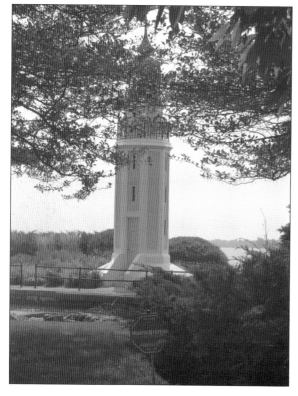

The electricity used to operate the lighthouse was furnished by the Cook & Brown Lime Company until the late 1930s. Eventually, John Thompson's son-in-law John Buckstaff purchased the property in the mid-1940s and proceeded to build a new ranch-style home on the property.

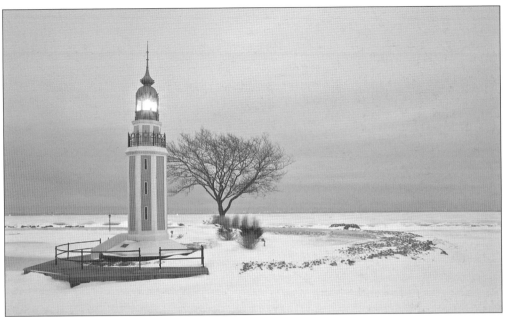

Bray's Point Lighthouse has been known by many names, including the Rockwell Light. Wisconsin senator William Bray could not convince the state to build a lighthouse at the spot to protect boaters, so he built the tower himself. This is the only privately built and owned lighthouse on Lake Winnebago. (Courtesy of the Oshkosh Public Library.)

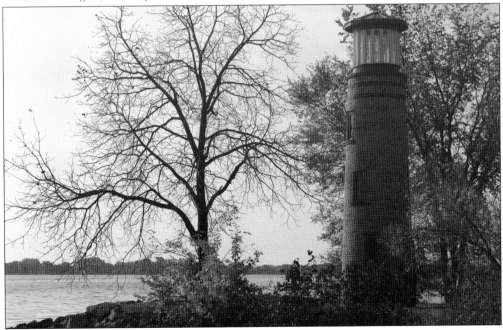

Oshkosh can lay claim to having the shortest functioning lighthouse on Lake Winnebago. During the Depression, the federal government created the Work Projects Administration (WPA) to supply needed jobs for citizens throughout the country. The Wisconsin Conservation Commission applied for federal dollars to continue the state's rough fish removal program, which included the need to build a lighthouse to the entrance of a future boat refuge and fish-processing stations.

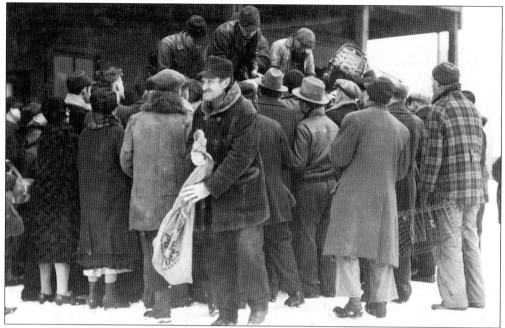

Jobs were scarce during the 1930s, and many families plunged into poverty. The lack of income also meant food for the kitchen table was rationed. The Wisconsin Conservation Department previously implemented the rough fish removal program on Lake Winnebago, which ended up supplying residents with a source of free meat while helping to improve the game fish in the lake. (Courtesy of the Oshkosh Public Library.)

A station house was built in Oshkosh as a place to process and distribute the netted rough fish to residents; the rough fish was also sold to other states. Contracted fishing boats would arrive at the station to unload the day's catch. The practice of rough fish removal from Lake Winnebago started in the early 1900s. (Courtesy of the Oshkosh Public Library.)

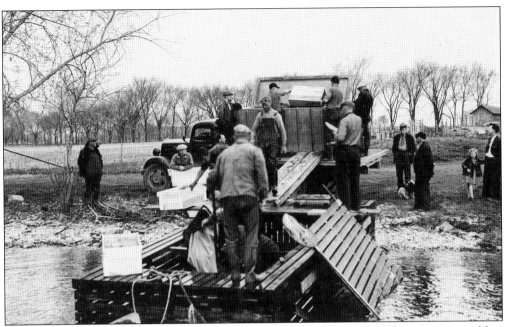

The rough fish removal was also financed by the sale of the fish caught. The carp went to New York by rail, and the sheepshead were transported to Chicago. The culls were sold to mink farmers for feed, and the leftovers were buried. The larger cities provided a good market for the rough fish for human consumption, but the residents around Lake Winnebago never developed a taste for the fish. Pictured below are workers lifting a loaded net of fish. Once the fish were contained in a smaller area in the bigger net (after the slack was taken up), hand nets were used to scoop up the fish. Large vessels would bring the loaded nets to the station onshore; there, men would handle the day's catch. (Above, courtesy of the University of Wisconsin; below, courtesy of the Oshkosh Public Library.)

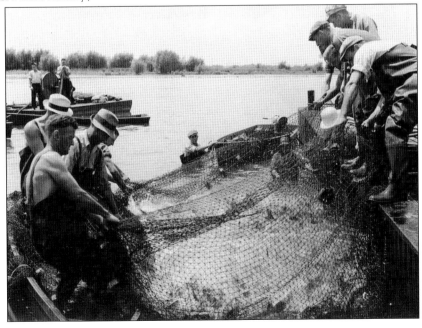

Conservation 20585 2D-1808	314998 REGISTRY NO.	7422 LETTER NO.	12-9-37 PRES. APP. DATE	7348	042,352 O. P. AMOUNT	465-53-2-279 O. P. NUMBER
GPO 16—5203 STATE NUMBER	9 DUR. MO.	49 Wisc. STATE	999 CITY	070 Winnebago COUNTY	490 TYPE	(BREAKDOWN) (LOCATION) COMPLETED

LIMITATION b 2

ACTION	DESCRIPTION 965 Wisconsin Conservation Department		
App. PA 11-15-37 042,352	County-wide. Make stream and lake improvements; construct, expand and repair warden quarters facilities; construct and repair boats and boat trailers; build barge, fish crib, and fish bldgs., also construct, expand and repair shelters, feeding hoppers, and stations for breeding and development facilities for game birds and animals; and performing appurtenant work. Project will operate throughout Winnebago County. State, county and privately owned property. Proper easements have been obtained for all work on private property, and no improvements will be made to private property. In addition to projects specifically approved. For Subsequent Proj. See O.P. 665-53-594 Continuation of APM 165-55-5501 4630 2D-1166; 65-53-100 2D-30 WP 190		11-12-38 1-27-39

WARRANT NUMBER nq

DATE COMPT-GEN. APP.	57,546 FEDERAL MAN-HOURS	88-91 % FEDERAL LABOR TO TOTAL F. F.	19 % SPONSORS FUNDS TO TOTAL COST	**1937**		
SUPPLEMENT						
1 6	55 TOTAL M-Y	55 FEDERAL M-Y	74 AVE. EMPL.	0775 M-Y COST.F. F.	052,372 TOTAL ALL FUNDS	
2 7						
3 8	058,592 LABOR	05,760 OTHER	042,352 TOTAL	01,440 LABOR	010,020 TOTAL	
4 9		FEDERAL CONTRIBUTION		SPONSORS FUNDS		
5 10						

30453 Rough Fish Removal 2D-2077	418634 REGISTRY NO.	2447 LETTER NO.	9-25-38 PRES. APP. DATE	9031	052,680 O. P. AMOUNT	665-53-2-275 O. P. NUMBER
GPO 16—5203 STATE NUMBER	12 DUR. MO.	49 Wis. STATE	999 CITY	070 Winnebago COUNTY	442 TYPE	(BREAKDOWN) (LOCATION) COMPLETED

LIMITATION 2 1

ACTION	DESCRIPTION 965 Wisconsin Conservation Commission		
App. WPA 9-16-38 $52,680	County-wide. Improve lakes and streams, for game fish and wildlife conservation purposes, throughout Winnebago County, including eliminating stumps, logs, and other obstructions; removing rough fish; constructing shelter buildings, fish ponds, and equipment necessary for the removal of rough fish; and performing incidental and appurtenant work. State and county owned property. The sponsor has jurisdiction to conduct the project on this property. In addition to projects specifically approved. Superseded by 10022 65-1-53-99 2D-2261 WRR: md		11-14-38 10-27-39

WARRANT NUMBER Bureau of Fisheries

DATE COMPT-GEN. APP.	106,904 FEDERAL MAN-HOURS	78-87 % FEDERAL LABOR TO TOTAL F. F.	30 % SPONSORS FUNDS TO TOTAL COST	**1938**		
SUPPLEMENT						
1 6	1,046 TOTAL M-Y	1,034 FEDERAL M-Y	87 AVE. EMPL.	$611 M-Y COST F. F.	$74,760 TOTAL ALL FUNDS	
2 7						
3 8	45,680 LABOR	$7,000 OTHER	052,680 TOTAL	2,400 LABOR	22,080 TOTAL	
4 9		FEDERAL CONTRIBUTION		SPONSORS FUNDS		
5 10						

The Asylum Point Lighthouse was funded through the Federal Work Projects Commission as part of a larger overall project. All paperwork involving the planning and construction of the lighthouse has long disappeared on both the state and federal level. The only remaining documents dating from prior to its construction are these two authorized project groups, which would have contained the funding to build the beacon. (Courtesy of the University of Wisconsin.)

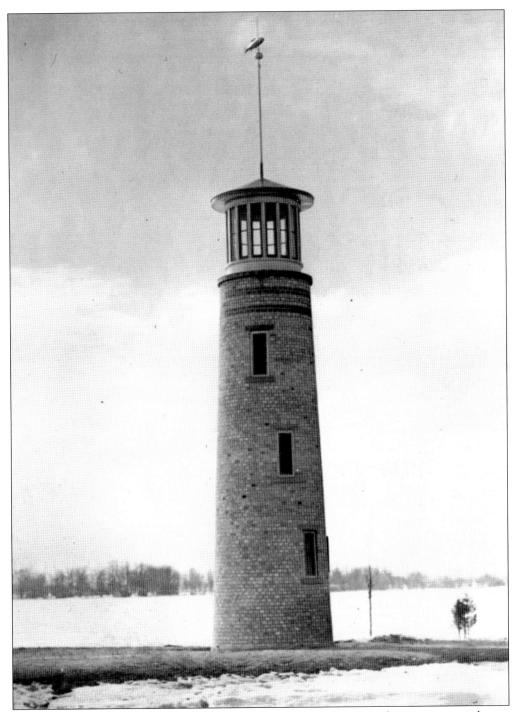

The Asylum Point Lighthouse was finished in 1940, and this picture was taken upon its completion. The structure was 42 feet tall to the tip of the flagpole. The original plans called for a flasher light with a visibility of 12 miles onto the lake during good conditions. The flashing light was never installed and an oil-filled lantern was carried to the light deck for illumination, alas for only a brief time. (Courtesy of the Wisconsin Department of Natural Resources.)

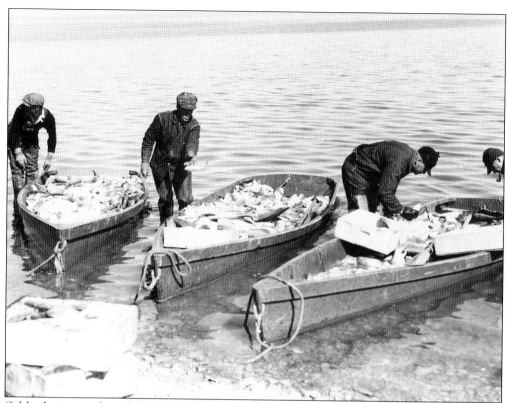

Oshkosh was not the only location on Lake Winnebago that supported rough fish removal; Fond du Lac and Calumet Harbor also participated. An average of one million pounds (500 tons) of rough fish were removed from Lake Winnebago from 1934 through 1940. In the prior 22 years, only 46 million pounds were removed from the lake. The WPA implemented a new rough fish removal program in 1938, but the federal program was slated to end on June 30, 1940. (Both, courtesy of the University of Wisconsin.)

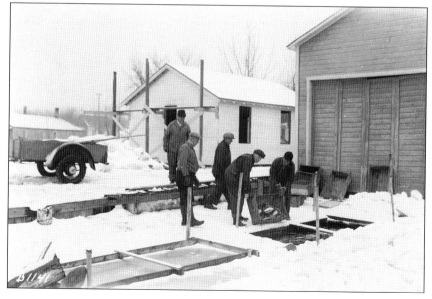

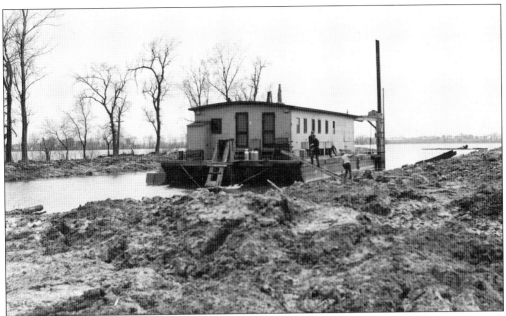

The Asylum Point Lighthouse was planned and constructed to aid in navigation of the barges and boats working under the rough fish removal program. The beacon was never officially authorized as a recognized navigation light by the government, and the tedious task of climbing the ladder to the light deck with a kerosene lantern was eventually discontinued. (Courtesy of the University of Wisconsin.)

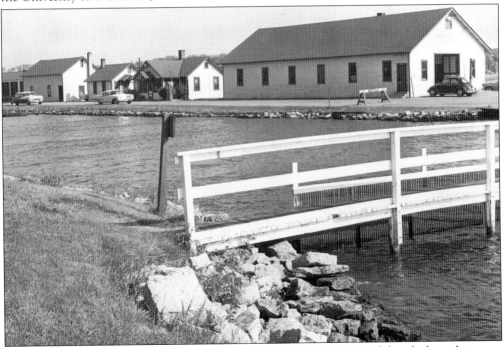

The entire rough fish facility location was originally chosen because of the ideal conditions to build a fishpond. A large portion of the area the facility sits upon was artificially filled in by approximately 125 WPA workers. (Courtesy of the University of Wisconsin.)

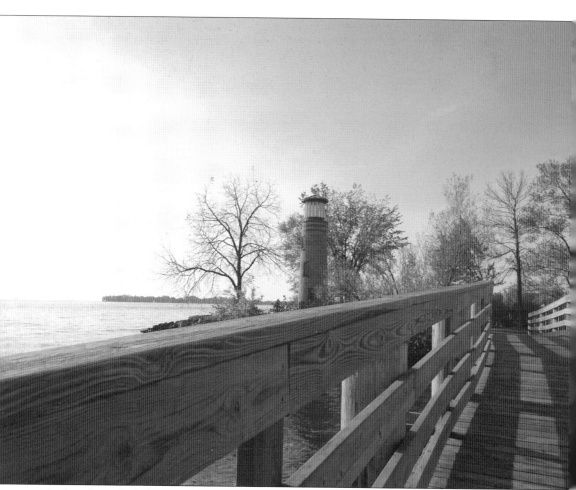

Asylum Point Lighthouse is located on a small island that is 600 feet long by an average of 75 feet wide. The land was originally marshy but was filled in for the construction of the beacon. The island was also designed for picnickers to enjoy and once had four open-air fireplaces for residents to use.

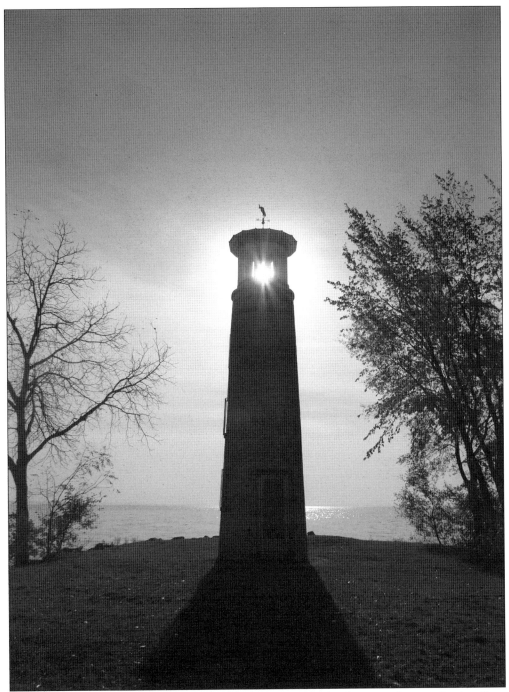

When the beacon was built, a gravel road was also constructed to bring residents to the site. Over three-fourths of a mile long, it took visitors on a winding, scenic route. As the road was being excavated, the workers discovered that it went through an important Indian burial ground.

The lighthouse was a simple, functional structure with no modern-day amenities. No electricity or water was ever brought to the beacon, and the keeper was greeted with a simple, vertical ladder upon entering the ground level.

Not the easiest lighthouse to navigate while carrying a lantern, the ladder shoots straight up and passes through three small openings in the evenly spaced landings.

There are three small viewing windows on the ground floor and two of the levels leading up to the lantern deck. The function of these windows was to allow light inside and give illumination on each landing for the keeper.

Pictured is the view looking down the inside of the Asylum Point Lighthouse when standing on the last level slightly below the lantern deck windows.

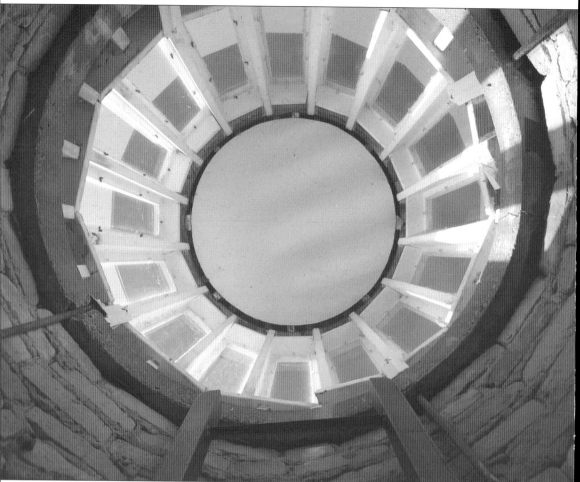

Looking straight up from the last standing platform within the lighthouse, the intended lantern deck area is visible. Since a recent renovation, the original lantern deck area has been repaired and replaced. A lantern platform or hanging apparatus for an oil lantern no longer exists.

Pictured is the view of Lake Winnebago from the lantern deck. The area consists of 16 vertical windows encompassing the entire circumference of the top section of the lighthouse.

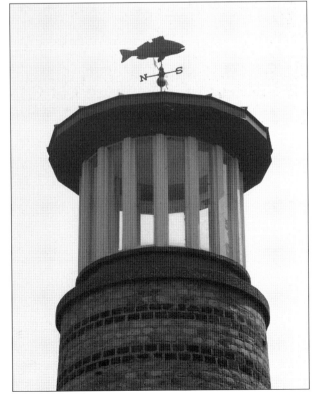

The entire top section of the lighthouse needed repairs, so in 2007, it received a makeover. Inmates at the nearby Winnebago Correctional Institute supplied the labor, and the job involved replacing parts of the wooden lantern room, refitting the windows, and rebuilding the metal roof. The original flagpole was removed and replaced with a copper fish weather vane.

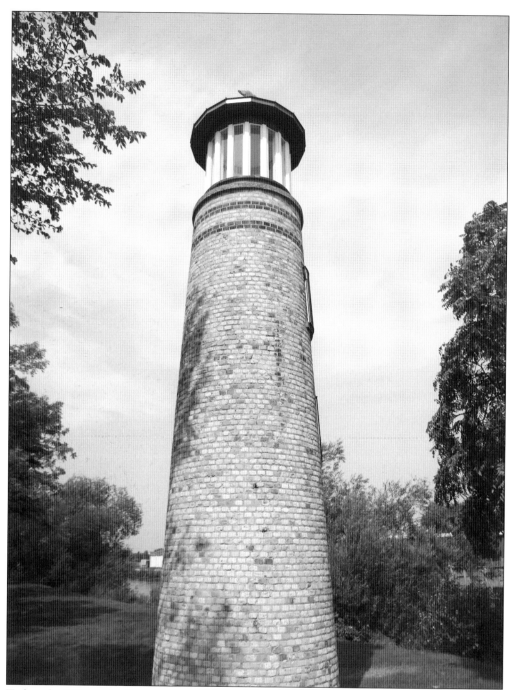

Today, the Wisconsin Department of Natural Resources still operates the fish station located along the shore. During the lighthouse restoration in 2007, there was an attempt made to place a solar or electric light inside the lighthouse to once again illuminate the structure, but the plans were abandoned due to Transportation Security Administration concerns.

Five

FOND DU LAC
LIGHTHOUSES

At the southern point of Lake Winnebago lies the city of Fond du Lac, which means "Foot of the Lake" in French; it was called White Bosom Village in the early 1800s. The city started out as a trading post near the forks in the Fond du Lac River in 1787, with the only means of travel being by canoe or on foot on Indian trails. James Doty, along with George McWilliams and others, had a direct hand in the formation of the area through investments. Doty and his partners thought the location would be a good site for a city, so they invested their money by purchasing several thousand acres of land in the area and dividing the property into lots.

During the 1800s, Fond du Lac carved out its own spot on Lake Winnebago with a diverse manufacturing base, which included machine shops, foundries, four mills, sash and door factories, saw mills, shingle mills, and carriage manufacturers. The extensive amounts of manufactured goods made in Fond du Lac created a demand that reached well to the north, south, and west of the city. As with all major communities sitting along Lake Winnebago shores, the primary mode of moving the commodities was by use of water, and then rail. By 1873, the cumulative amount of goods made and sold by Fond du Lac factories exceeded $5 million annually, and shipments were going out to residents and shops in Fond du Lac, Sheboygan, Winnebago, Calumet, and Dodge Counties.

Fond du Lac was the only other location, besides Menasha, on Lake Winnebago where the federal government planned on constructing a lighthouse. In 1872, the US government appropriated $20,000 for the construction of a lighthouse at the mouth of the Fond du Lac River.

The proposed lighthouse was never built, as the anticipated boat traffic in that area never reached higher than one or two boats per day. The government finally decided that there was no justification for the beacon and scrapped the project. The project cancellation came after speculation of the lighthouse rose high enough that mapmakers marked the lighthouse location on maps of the area, like this one from the 1870s.

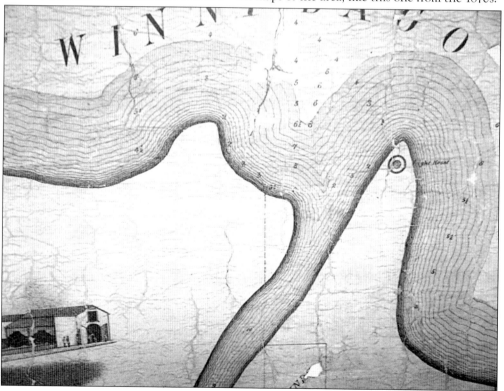

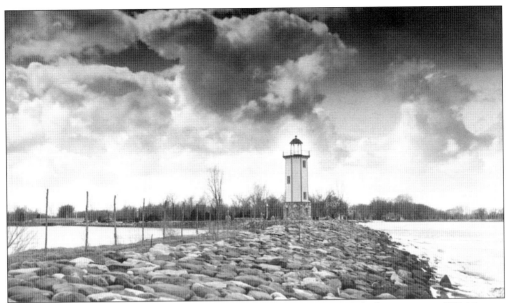

About 60 years later, during the Great Depression, an offer was made by businessman W.J. Nuss to construct a lighthouse next to the Fond du Lac Harbor in Columbia Park. The Fond du Lac Park Board quickly accepted the generous offer from Nuss in 1932. The Fond du Lac Lighthouse was built in 1933 at no cost to the city. The laborers who constructed the beacon were all out-of-work Fond du Lac residents. The wages and material were paid using generous donations made by Mayor Albert J. Rosenthal, W.J. Nuss, Pierce Pereell, E.A. Becker, W.H. Manoske, H.B. Rossner, and A.R. Reiser. The laying of the cornerstone was done on July 10, 1933, amidst a large celebration with several hundred people in attendance. Mayor Rosenthal assisted park board members in laying the cornerstone. (Courtesy of the Fond du Lac County Historical Society.)

Fond du Lac needed a beacon for its harbor to help boaters navigate into it. The lighthouse was built for navigation and as a tourist attraction, allowing visitors to climb its interior staircase and view the surrounding area from the observation deck. The harbor also was, and remains, a very productive and popular fishing area. (Courtesy of the Fond du Lac County Historical Society.)

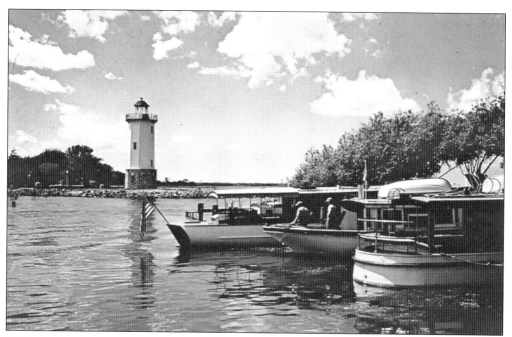

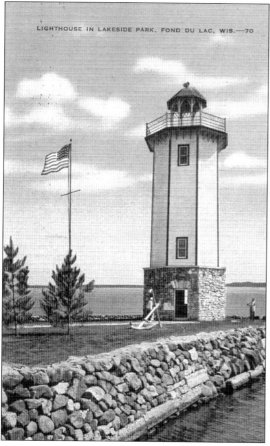

LIGHTHOUSE IN LAKESIDE PARK, FOND DU LAC, WIS.—70

The plans for the lighthouse were also a donation and came from architect Roger Sutherland, who was a Fon du Lac native and went to Ripon College to learn his trade. Sutherland later moved to Milwaukee and became a well-established architect in that area. He would periodically travel back to his home town for events like being master of ceremonies for Fond du Lac high school graduations. (Courtesy of the Fond du Lac County Historical Society.)

Fond du Lac Park Department superintendent Frank Russell was in charge of the lighthouse's construction. The lighthouse was a wood-frame octagonal structure, except for the flagstone base. The entire project was completed in October 1933.

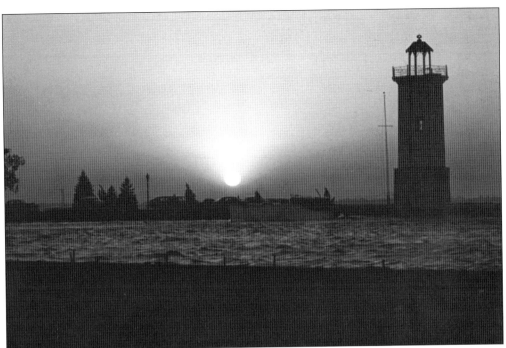

During construction, the new lighthouse gained attention throughout the Lake Winnebago area and the state. In June 1933, the second annual motorboat cruise on Lake Winnebago included the new lighthouse in the festivities. (Courtesy of the Fond du Lac County Historical Society.)

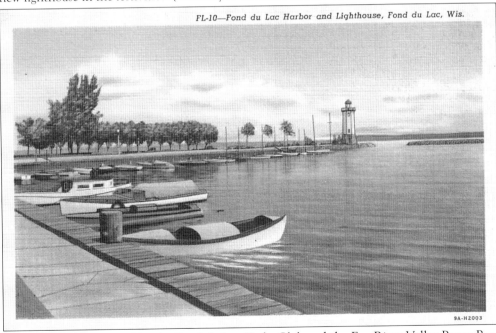

FL-10—Fond du Lac Harbor and Lighthouse, Fond du Lac, Wis.

9A-HZ003

The event was sponsored by the Fond du Lac Yacht Club and the Fox River Valley Power Boat Association. The procession started in Appleton and headed out on Lake Winnebago to Oshkosh, where more boats joined in. From there, more than 100 boats set course for the Fond du Lac harbor, where Wisconsin governor Albert Schmedeman gave a speech and dedicated the lighthouse.

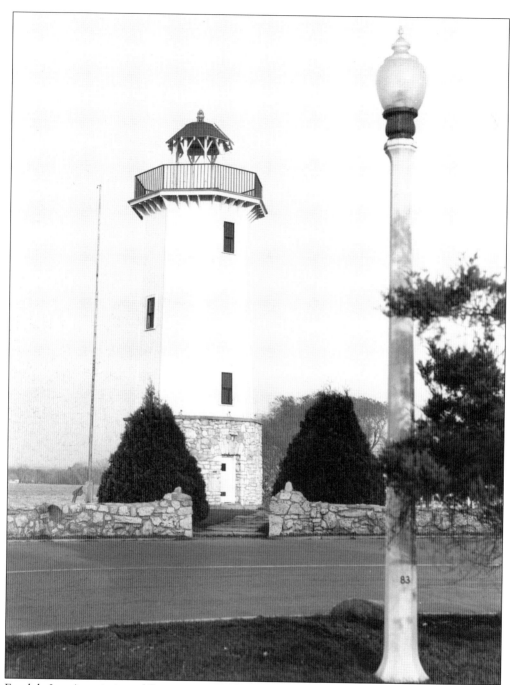

Fond du Lac Association of Commerce president Herman Berndt stressed the importance of the harbor and lighthouse to tourism and recreational boating during the dedication ceremony. Judge Heinemann, commodore of the Valley Association, also spoke and focused on the importance of Lake Winnebago being used for business purposes. In the mid-1960s, the lighthouse fell into disrepair, and the structure became unsafe and was covered with graffiti. A drive was started in 1966 to raise money to restore the beacon back to its original condition. Approximately $8,000 was raised for the project, and the lighthouse was rededicated on July 3, 1968.

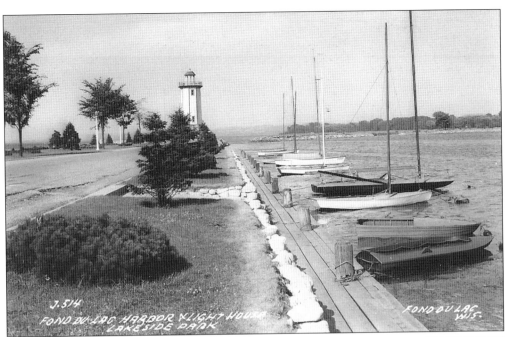

The Fond du Lac Harbor has changed throughout the years. Initially, there were moorings running down the shoreline where boat owners could secure their watercraft. The mooring system was later removed and replaced with a network of docks that would accommodate more boats and provide safer access for the public.

The Fond du Lac Lighthouse provided many opportunities for locals and visitors to just gaze out onto a picture-perfect background. Even on a foggy day, the lighthouse would present itself as a majestic tower that would draw the eye to it. (Courtesy of the Fond du Lac County Historical Society.)

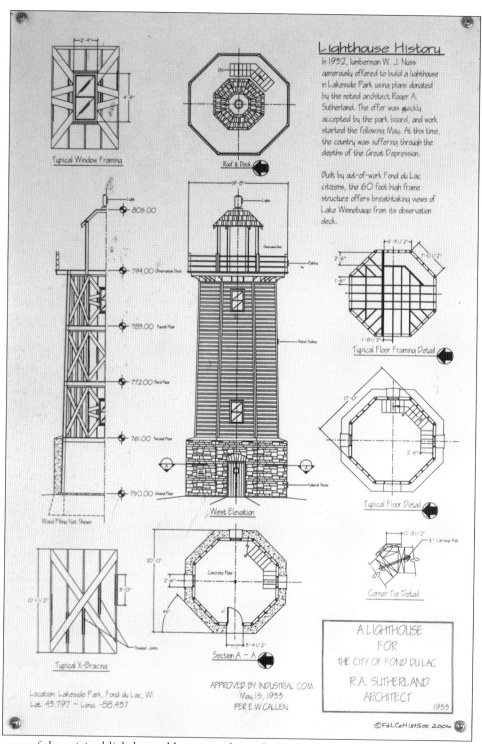

Lighthouse History

In 1932, lumberman W. J. Nuss generously offered to build a lighthouse in Lakeside Park using plans donated by the noted architect Roger A. Sutherland. The offer was quickly accepted by the park board, and work started the following May. At this time, the country was suffering through the depths of the Great Depression.

Built by out-of-work Fond du Lac citizens, the 60 foot high frame structure offers breathtaking views of Lake Winnebago from its observation deck.

Typical Window Framing

Roof & Deck

Typical Floor Framing Detail

Typical Floor Detail

Corner Tie Detail

West Elevation

Section A ~ A

Typical X-Bracing

Location: Lakeside Park, Fond du Lac, WI
Lat. 43.797 ~ Long. -88.437

APPROVED BY INDUSTRIAL COM.
May 15, 1933
PER E.W.CALLEN

A LIGHTHOUSE
FOR
THE CITY OF FOND DU LAC

R.A. SUTHERLAND
ARCHITECT
1933

© FdLCoHistSoc 2006

A copy of the original lighthouse blueprints, drawn by Sutherland in 1933, is on display inside the structure on the first level. This blueprint duplicate was done by the Fond du Lac County Historical Society in 2006.

The observation deck is 19 feet, 8 inches in diameter with the operating light placed on top of the observation deck's roof. The beacon light was bought by the Fond du Lac Yacht Club for approximately $200 and donated for the project. The public access observation deck is 44 feet off the ground, with the beacon sitting 11 feet above that, giving the tower a total height of 55 feet. The interior consists of four stories with inside heights of 11 feet each.

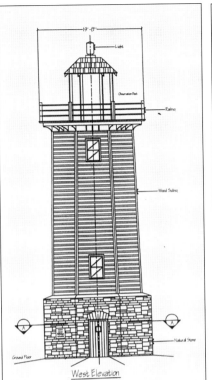

West Elevation

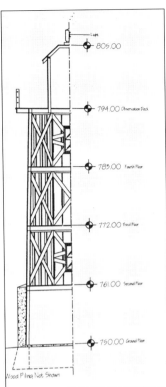

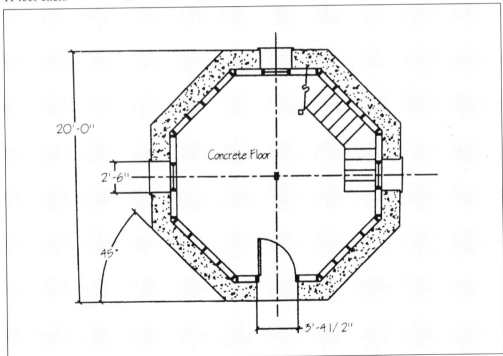

The 20-foot-diameter base and bottom level set the tone for the entire structure. It is a simple octagon shape with two windows and a staircase leading to the second level.

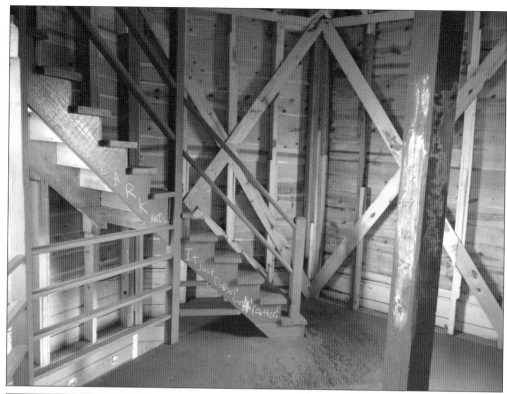

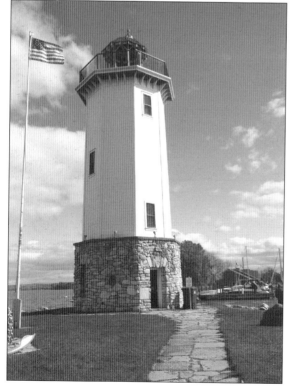

The Fond du Lac Lighthouse was, and is, an unmanned beacon built for public enjoyment. The interior is a strict utilitarian construction made for heavy foot traffic of visitors going up to the observation deck. Each interior level is identical, nothing more than an open room with a staircase that hugs the exterior wall of the tower.

Since the main building material used is wood, the lighthouse needs periodic maintenance and repair. During 1993, the lighthouse was restored, and its roof was replaced due to rotting. The name of the harbor adjacent to the lighthouse property is called Lighthouse Harbor; this name was adopted in 1935 after the construction of the beacon. Prior to the building of the structure and dredging of the harbor itself, it was originally called the Big Hole.

The Calumet Harbor Light is the second of two navigation structures on the shores of Lake Winnebago to allow entrance to the public. The tower is 75 feet tall and marks the entrance to Pipe Creek.

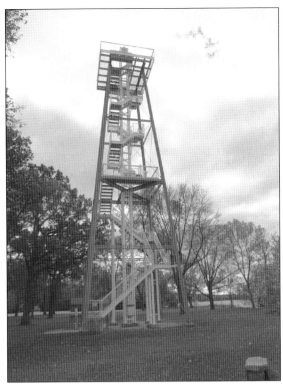

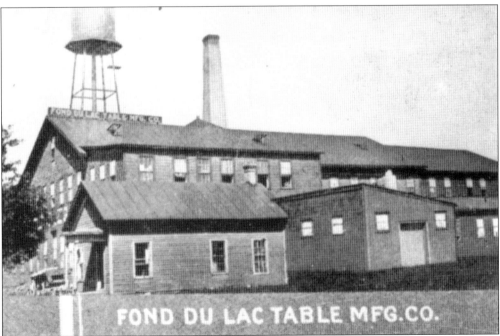

The tower used to hold the beacon was originally the support tower for the Fond du Lac Table Factory water tower shown here. In 1936, the water tower was disassembled and relocated to the present location to serve as the platform for the navigation beacon. (Courtesy of the Fond du Lac County Historical Society.)

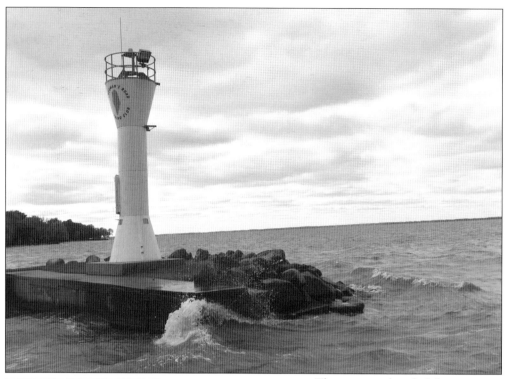

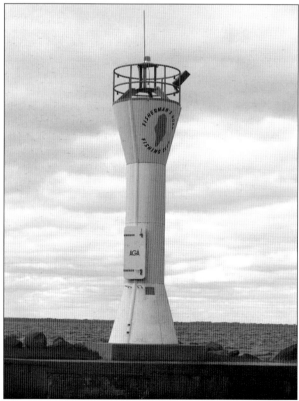

The most modern lighthouse along the shores of Lake Winnebago is the Fisherman's Road Lighthouse. The beacon marks the entrance to a marina operated by the Fisherman's Road Fishing Club. It was not always known as the Fisherman's Road Lighthouse because its original location was alongside the Calumet Harbor light tower just three miles to the north by Pipe Creek. The tower was relocated to its present location in 2001.

Six

ROAD TRIP

The Lake Winnebago lighthouses provide perfect sightseeing outings for local families. A trip around the lake is less than 100 miles, affording a great one-day getaway the entire family can enjoy. All lighthouse locations, except for the Bray Lighthouse, are within public parks or public boat launches. Because of this, visitors can relax and even picnic at each lighthouse. The Bray Lighthouse is not included in this section because it sits on private property in a residential neighborhood and can barely be seen from the road because of tree growth.

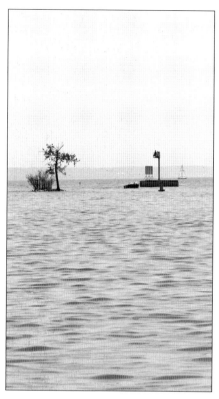

Even though the lighthouse has not been in existence in a very long time, it is still possible to visit the location either by boat or by land. To view the Menasha location on land, drive to Jefferson Park in Menasha and park by Peanut Island. The lighthouse was located farther out and to the left of the small island near the mouth of the river.

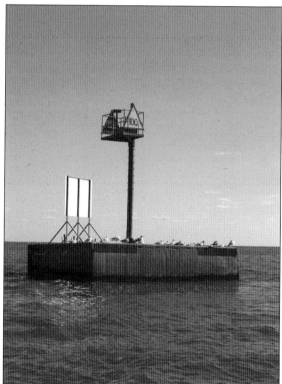

By boat, go approximately 2,000 yards past Buoy 100 and navigate over the shallow reef. But boaters beware—many mariners have damaged their boats when going over the reef.

Peanut Island is a small piece of land connected to shore by a single bridge. A landmark cannon sits upon the island.

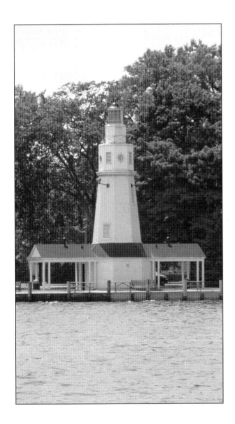

The Neenah Lighthouse can be seen in the city of Neenah's Kimberly Point Park.

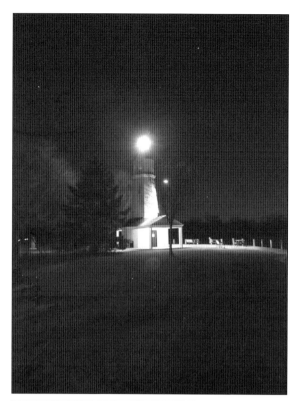

The lighthouse is functioning and can be visited after dark; however, the tower is not open to the public, only the grounds surrounding the beacon.

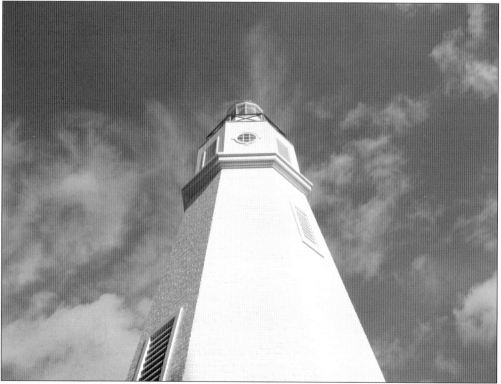

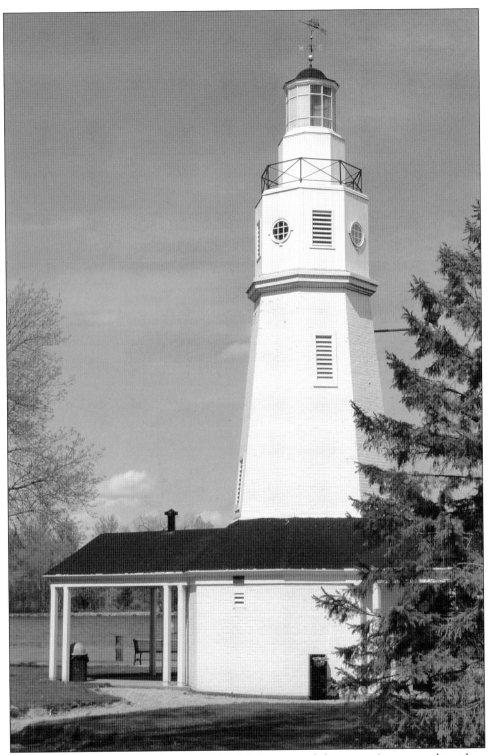

There are public restrooms at the base of the lighthouse, and the women's restroom has a bonus feature—the entrance to the tower is here, offering a good view of the inside.

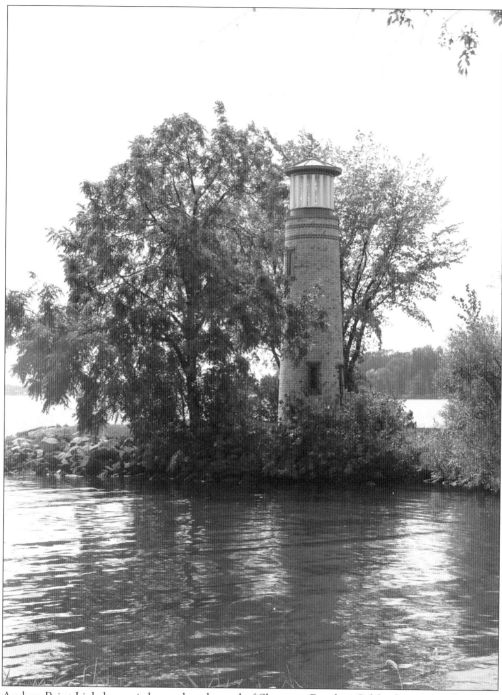

Asylum Point Lighthouse is located at the end of Sherman Road in Oshkosh on a small island.

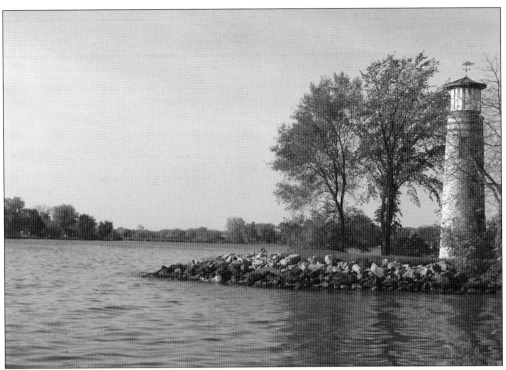

The area is part of the park system, and the entire grounds surrounding the lighthouse are accessible to the public.

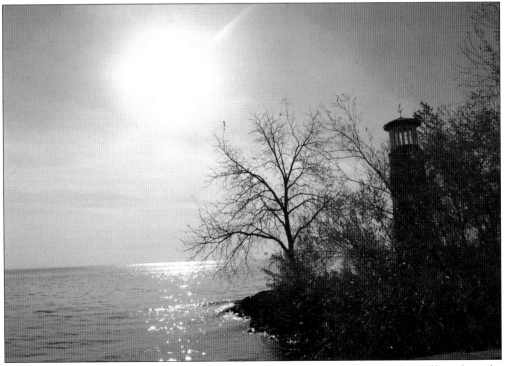

The tower itself is not open to the public, but groups can schedule tours and are allowed inside.

The Fond du Lac Lighthouse is located at the end of Lighthouse Drive in Fond du Lac.

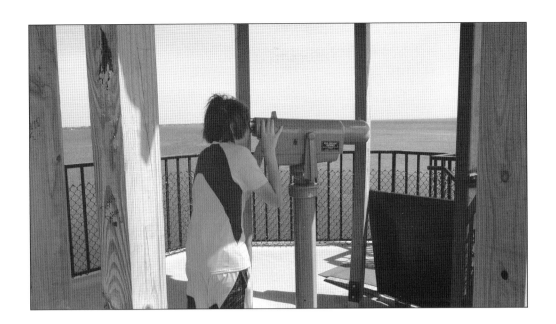

The tower is open to the public, and on the top deck, there is an observation telescope for viewing the distant shores of the lake. The observation deck provides 360 degrees of viewing the harbor and lake.

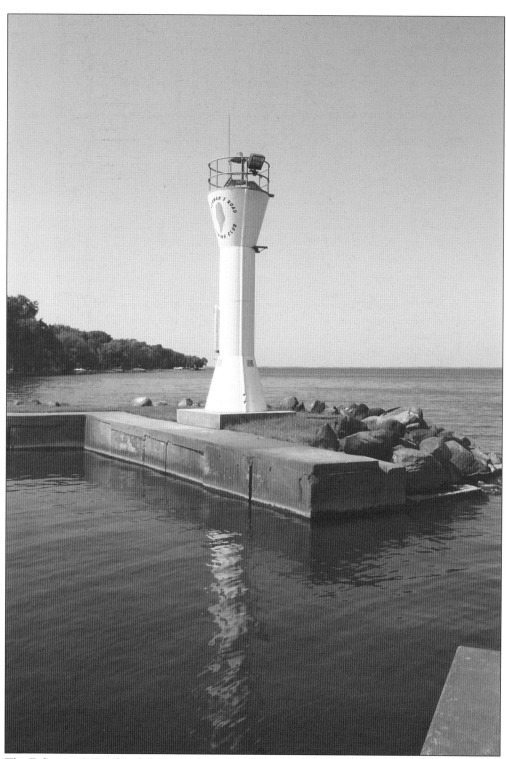

The Fisherman's Road Lighthouse is located on the east shore of Lake Winnebago at the end of Fisherman's Road, between Pipe and Fond du Lac on Highway 151.

Calumet Harbor Lighthouse is located on the east side of Lake Winnebago in Columbia Park outside of Pipe.

The tower is open to the public and has 112 steps leading up to the dizzying height of the viewing platform. The platform provides an unmatched view of Lake Winnebago.

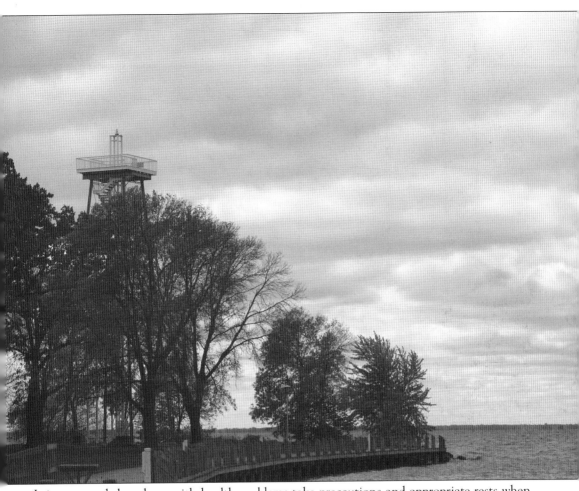

It is suggested that those with health problems take precautions and appropriate rests when ascending and descending the tower.

DISCOVER THOUSANDS OF LOCAL HISTORY BOOKS
FEATURING MILLIONS OF VINTAGE IMAGES

Arcadia Publishing, the leading local history publisher in the United States, is committed to making history accessible and meaningful through publishing books that celebrate and preserve the heritage of America's people and places.

Find more books like this at
www.arcadiapublishing.com

Search for your hometown history, your old stomping grounds, and even your favorite sports team.